IMAGES
*of America*

# JERSEY CITY
# MEDICAL CENTER

IMAGES
*of America*

# JERSEY CITY
# MEDICAL CENTER

Leonard F. Vernon
Foreword by Jonathan M. Metsch, Dr.P.H.

ARCADIA

First published 2004

Published by Arcadia Publishing
Charleston SC, Chicago IL, Portsmouth NH, San Francisco CA

Printed in Great Britain

Library of Congress Catalog Card Number: 2004108186

For all general information, contact Arcadia Publishing:
Telephone 843-853-2070
Fax 843-853-0044
E-mail sales@arcadiapublishing.com
For customer service and orders:
Toll-free 1-888-313-2665

Visit us on the Internet at www.arcadiapublishing.com

# CONTENTS

*To Sandie, Jeff, Rachel, Aislinn, Shayna, and Alyssa*
*with all my love.*

# FOREWORD

When I was asked to write the foreword to this special book, I thought of the many things I could recall about the legendary old Jersey City Medical Center: its majesty over Jersey City from the Palisades; its beautiful architecture and elegant interior; its colorful political history and mythology, including Mayor Frank Hague; and its history of providing high-quality medical and nursing care and education right here in Jersey City.

We moved to the new medical center on May 16, 2004. As I walked through the corridors of our magnificent new hospital, I felt there was still something left behind on Baldwin Avenue. It was then I realized just what this book was about.

This book is the biography of a building and the people who worked there, a story about people told in photographs, people who helped make the Jersey City Medical Center and its affiliates, the Margaret Hague and Pollak Hospitals, the best of their times.

The many photographs of the nursing students and of the medical and dental schools that once operated at the medical center instill a sense of pride of the educational history that took place on that plot of land. The images, some of which date back nearly 100 years, also reveal the hardships physicians and nurses had to overcome in taking care of the very sick and very poor. These professionals did so while maintaining their patients' respect and dignity.

Community service is what the Jersey City Medical Center is about. This was reflected on September 11, 2001, when the medical center established command centers at Liberty State Park and the waterfront. Thousands of survivors fleeing from New York City were triaged, and at the hospital, 175 victims were treated.

Although the photographs are a splendid visual history of the old Jersey City Medical Center, this book is more about the people who helped make the medical center the place it was, is, and will be forever—a beacon of hope offering the best medicine anywhere.

—Jonathan M. Metsch, Dr.P.H.

# ACKNOWLEDGMENTS

When I first decided to undertake this project, I had no idea of the amount of work involved in putting together a book of photographs. To the reader of the finished product, the book may appear to be simply a collection of photographs that have been copied and placed in chronological order in a bound volume. This, however, is not the case. First of all, many of the photographs themselves were difficult to locate since they were not in a single repository. Although the Jersey City Public Library maintains a very good collection with an easy-to-use filing system, photographs elsewhere were found stored in boxes or in filing cabinets. Secondly, the text that accompanies each photograph required extensive research. That research sometimes uncovered contradictory information from various sources, requiring that a primary source be located—not an easy task.

Fortunately, some photographs were identifiable, thanks to the late Gerald Nissenbaum, M.D., the unofficial Jersey City Medical Center historian. Nissenbaum, who practiced here for more than 40 years, was emotionally attached to the hospital and knew a lot about it, according to the staff. He spent hours going through old photographs in the hospital library, identifying the individuals in the pictures, most of whom were long deceased.

Others who made the research much easier were the very able and accommodating staff members of the New Jersey Room of the Jersey City Public Library, a place with information about anything and everything about both New Jersey and Jersey City. Cynthia Harris, one of the first people called upon, was extremely helpful and encouraging. Early in the morning, Joe Donnelly, after graciously accepting coffee and a doughnut, was of great help in finding photographs in the library's archives. Charlie Markey and Bruce Brandt willingly faxed me pages from documents. I cannot say enough about all of these individuals.

Of course, this book would not have been possible without the assistance and cooperation of the Jersey City Medical Center itself. Members of the public relations staff, especially Sally Deering, who was in the middle of helping to coordinate the move from the old hospital to the new hospital, always found time for me. She and Judith Wilkinson, the head librarian at the center, gave me free and unhampered access to all of the photographic and printed material that was in their possession. Likewise, Lois Densky-Wolff, the head of the special collections department at the University of Medicine and Dentistry in Newark, was a great help in researching the Seton Hall College of Medicine and Dentistry, which operated for many years at the Jersey City Medical Center. Some very difficult to obtain photographs were made available thanks to the generosity of Bob Leach, director of the Jersey City Historical Project and author of *The Frank Hague Picture Book*, from which much information was gleaned.

Leon Yost, a professional photographer, took many of the more recent photographs that appear in the book. A Jersey City resident for more than 30 years, he was instrumental in the production of this book, and I thank him for all of his time.

Although the book is about a hospital, it reaches deeper, touching on the politics, as well as the citizens, of the city. It speaks of the healthcare of the future, as well as that of the past.

# INTRODUCTION

The Jersey City Medical Center and Mayor Frank Hague are inextricably linked. When Hague first envisioned a medical mecca, an average city hospital existed in Jersey City. It was a place where the poor went to receive medical care, as the more affluent received care in the comfort of their home.

Political historians have called Hague "one of the strongest political bosses America has ever seen." His influence was not limited to Jersey City or even to New Jersey; it, in fact, became national when he was selected to serve as vice chairman of the Democratic National Committee. With a reputation as a superb political strategist, Hague micromanaged. Under his direction public meetings and demonstrations became extraordinary exhibitions of pomp and circumstance. Gov. Franklin D. Roosevelt, running for president in 1932, said Hague's rally for him on the campgrounds of the National Guard at Sea Girt was the biggest and most impressive he had ever witnessed.

Hague grew up in the Horseshoe section, Jersey City's old Second Ward, an area of tenements and taverns. One of these taverns, at the corner of Cork Row, was run by Ned Kenny, the man who picked Hague to run for constable and gave him campaign money to finance the candidate's first political effort. Cork Row disappeared when the broad highway approach was constructed to the Holland Tunnel.

The Horseshoe was so named as the result of a Republican legislative gerrymander. In 1871, the Republican majority legislature attempted to concentrate all the Democratic voters in one assembly district and, in doing so, designed a district shaped somewhat like a horseshoe. The district consisted of poor immigrants and sons of immigrants who worked in the railroad yards and on the docks. These immigrants were mainly Irish and Roman Catholics. Some of the Irish felt that they were being "held down" by the Protestant landlords and employers who lived in luxury "up on the hill" in Jersey City's Bergen section. Hague took advantage of this resentment and did nothing to discourage the belief that equated being Protestant with being Republican.

Hague's rise to power was systematic; he served as constable in 1898, city commissioner 15 years later, and mayor four years after that. Within a year, he had control of the Democratic organization in Hudson County. Two years later, in 1919, Hague fielded Hudson's state Sen. Edward I. Edwards as a candidate for the party's nomination for governor against the powerful and astute James R. Nugent, the boss of Essex County and the heir to the leadership of U.S. Sen. James Smith Jr.

When Edwards beat Nugent, Hague proclaimed himself the state Democratic leader. With Edwards installed in the governorship, the seat of power moved from Newark to Jersey City. Edwards proceeded to appoint judges, prosecutors, and other state officials recommended by Hague. No political leader in New Jersey history had moved so fast and gone so far in such a short period of time.

Hague ruled with an iron fist and used his new power and prominence to build the seven skyscraper buildings that became known as the Jersey City Medical Center.

Many authors cite Hague's building of the hospital as typical of the man who has been presented as a Robin Hood type, taking from the rich and giving to the poor. Others have been more cynical in their observation of Hague's motives. Dayton David McKean, in his book *The Boss*, uses the phrase "Turning Hospital Beds into Votes: Socialized Medicine under the Hague Machine" to describe the building of the hospital. McKean attests to the political astuteness of Hague, saying that he has seen the way that lavish medical care can be used to disarm criticism, and that it is practicable to have children literally born into the organization, obligated to it from the first squalling moment. Cared for during the recurrent illness of youth, McKean continues, they come to associate health itself with the generous political party that has guided their city for decades; they will no more vote against Hague than against life. When they marry and have children of their own, McKean says, they, too, are born in the Margaret Hague Maternity Hospital. Finally, in the rheumatic pains of old age, they go to the hospital for care and comfort. Unless the end of life comes suddenly on the street or at home, they are likely to leave Jersey City as they came into it—although from a different building—indebted to the organization from the first moment to the last. They pay for the service—or someone does— but Hague gets the credit and the votes, McKean concludes.

The published cost of the land and buildings erected during the Hague administration is $21.9 million, which does not include the cost of the staff house, or nurses' home, estimated at an additional $5 million. A sizable portion of the money came from the federal Public Works Administration: nearly $6.4 million as a loan at 4 percent interest and $5 million as a grant.

On October 2, 1936, Pres. Franklin D. Roosevelt laid the cornerstone of the new medical building at the Jersey City Medical Center. This day was declared a public holiday by the mayor, with all schools and all public offices closed. Almost a quarter of a million people turned out to line the streets as the president drove through the city on his way to the ceremonies, accompanied by Mayor Frank Hague and other New Jersey politicians.

In his speech, Roosevelt stated, "The overwhelming majority of the doctors of the nation want medicine kept out of politics. On occasions in the past attempts have been made to put medicine into politics. Such attempts have always failed and always will fail."

# *One*
# THE CHARITY HOSPITAL

During the 19th century, Jersey City operated a variety of public facilities for the health and welfare of Jersey City's poor and sick. The pesthouse was opened *c.* 1805 in an isolated part of Paulus Hook to quarantine sufferers of contagious diseases. The "old cabin" that stood there was subsequently used as the county poorhouse until the Civil War and then for cholera cases afterward. In 1868, the city alderman created the Jersey City Charity Hospital on this site, and the cabin was replaced by a new building, in which the institution remained for about a dozen years.

By 1881, the city had determined that the old Paulus Hook site was no longer suitable, mainly because of the smoky conditions created by factory development in the area. The city acquired land at Baldwin Avenue and Montgomery Street, began construction of a new building, and immediately reopened the hospital in temporary quarters consisting of existing wooden houses and other ones moved to the site.

The medical and surgical patients, as well as the alcoholics (of which there were no small number), were housed in a mansion that was possibly once the home of Orestes Cleveland, mayor of Jersey City from 1864 to 1867 and again from 1886 to 1892. Obstetrical and pediatric patients were cared for in other smaller houses.

The new hospital building was ready for occupancy in December 1882. It was able to serve several thousand patients a year. Records indicate that in 1893, it was handling 4,095 surgical procedures, 1,972 medical dispensary cases, 691 ambulance calls, and 20,000 prescriptions. Each of the buildings of this hospital was eventually demolished, and a new hospital was built during the first administration of Mayor Mark Fagan (1902–1907), a progressive Republican. Begun in 1906, the new hospital was not completed and opened until 1909, during the administration of Mayor Otto H. Wittpenn, another progressive Republican.

This is a drawing of the first Jersey City Charity Hospital, which was built in 1868 on the site of the old pesthouse.

This 1892 photograph depicts one of the existing houses at the Baldwin Avenue location. The city used these existing houses and others that were moved to the site as a temporary hospital.

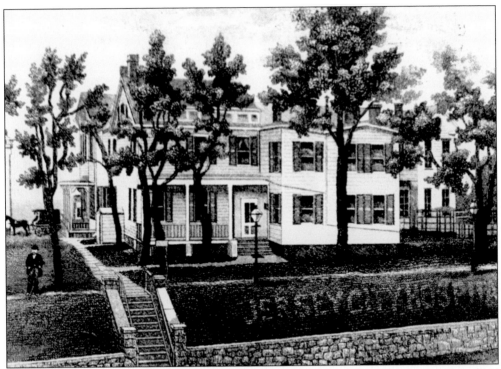

This is probably the home of Orestes Cleveland, who served as mayor of Jersey City from 1864 to 1867 and again from 1886 to 1892. It was used to house the medical and surgical patients, as well as alcoholics. The photograph dates from 1892.

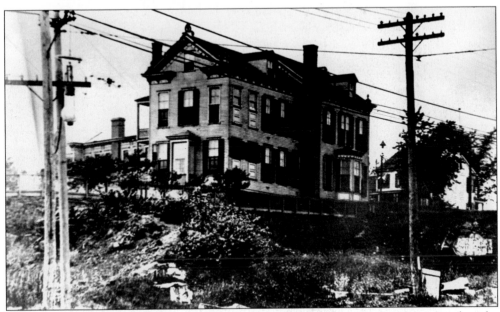

Standing parallel to Montgomery Street, this house (pictured c. 1890) either existed at the Baldwin Avenue site or was moved there to be used as a temporary hospital. In 1885, the hospital changed its name from Charity Hospital to City Hospital.

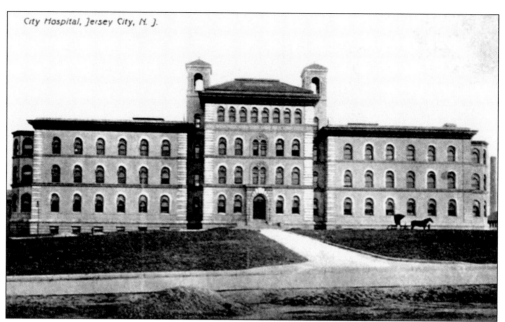

City Hospital, Jersey City, N. J.

Each of the buildings of the first hospital was eventually demolished, and a new hospital was begun during the first administration of Mayor Mark Fagan (1902–1907), a progressive Republican. The hospital was not completed and opened until 1909, during the mayoral administration of Otto H. Wittpenn, another progressive Republican.

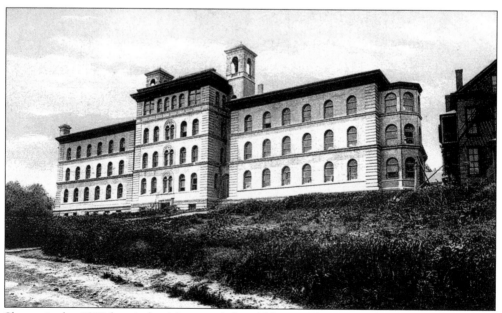

Shown is the 1909 hospital, with one of the old houses that was either on the grounds or transported there and used as a temporary hospital until the completion of the larger hospital.

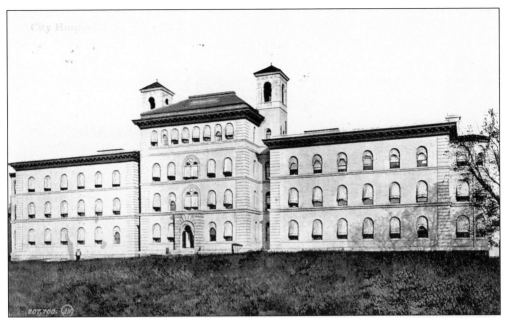

This 1909 view shows the peaceful atmosphere of the new hospital. It was a three-story brick structure, 21 bays long, with semi-octagonal bays at the east and west ends and five-story towers recessed between a projecting four-story central pavilion and a pair of three-story side wings.

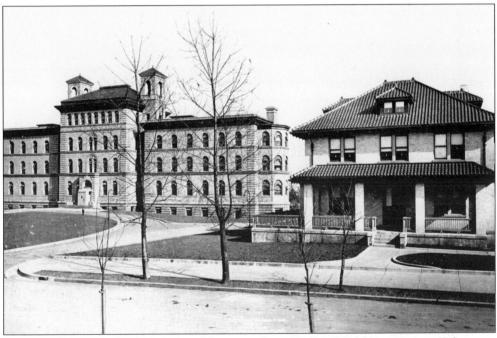

The new three-story brick structure, like its predecessor, faced Baldwin Avenue. Other new buildings were constructed to accommodate various support functions, including a staff house, morgue, chapel, and nurses' residence. These structures stood behind and to the south of the main building. In addition, a new warden's home, visible on the right, was built in 1908 or 1909. The hospital administrator was called the warden in the early 1900s.

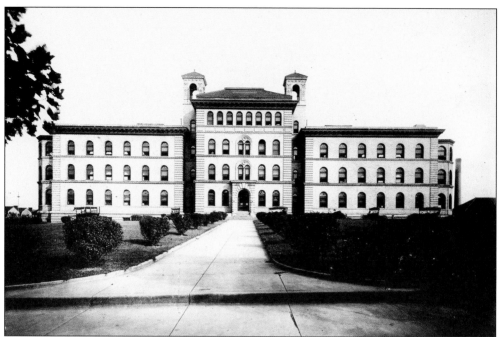

This 1916 photograph of the hospital reveals the setback from Baldwin Avenue, with the long walkway leading up to the hospital's main entrance.

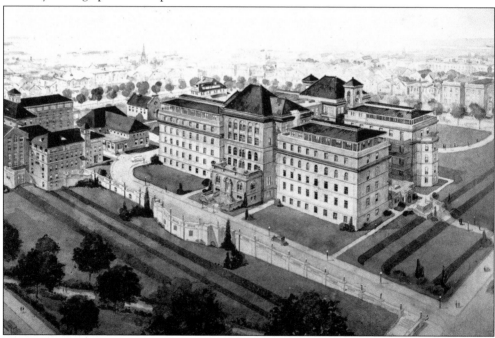

This artist's drawing is a view of the hospital from the back. In addition to the enlargement of the main building and the construction of a second building, other smaller buildings were added for auxiliary functions. A laundry and a powerhouse were combined in one building put up in 1917. The power plant enabled the hospital to generate its own electricity and to produce steam for heating more efficiently. These auxiliary buildings are seen to the left of the main hospital.

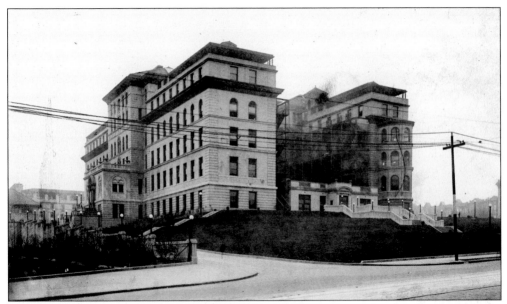

By 1917, the hospital was beginning to outgrow its current space, and construction was begun on a second, larger structure and on additions to the existing structure. Taken from Montgomery Street, this 1919 photograph shows the fourth-story addition on the existing structure and the second, larger building. The two main buildings, although built 10 years apart, closely matched each other in height and overall length, in style, in massing, and in many details.

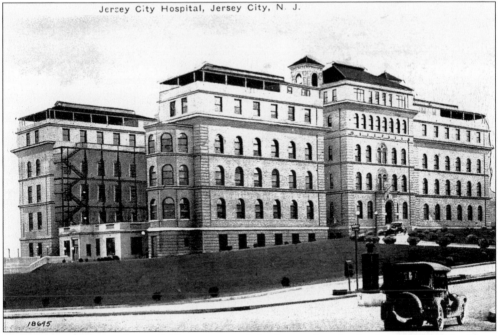

Jersey City Hospital, Jersey City, N. J.

This rendering shows the c. 1919 extension of the hospital at the back of the 1909 building. There were two wards of 25 beds on each of the first three floors of the building. The fourth floor contained a supply room, and x-ray room, sterilization room, and two operating suites, each with an induction room for anesthesia.

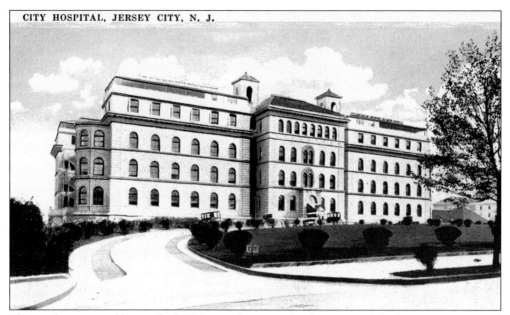

The newly renovated hospital of 1919 was a four-story brick structure. The basement contained the kitchen, pharmacy, clinic entrance, emergency room, and a wing with 10 cells for holding alcoholics. The first floor held offices for Dr. Mortimer Lampson, the hospital superintendent, and Molly Southerland, the directress of nursing. The hospital had no accommodations for psychiatric patients, who were held in the county jail.

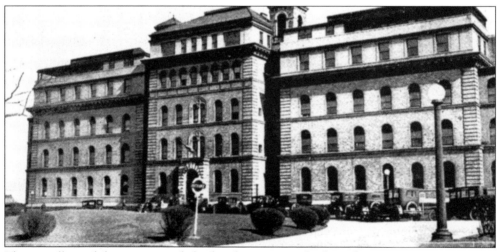

The semielliptical driveway provided vehicular access to the front door.

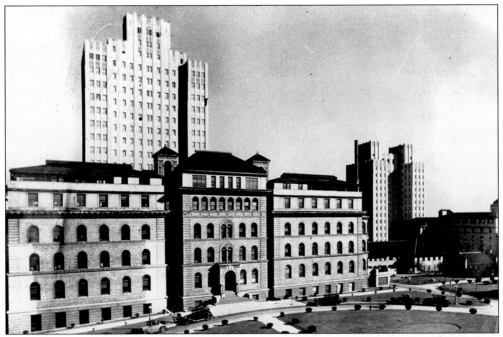

By 1932, the Jersey City Hospital had begun to develop a new look with the addition of a 22-story high-rise hospital unit known as Holloway (later commonly known as the surgical building), seen here behind the original 1909 building. To the right of the main building is the second of the high-rise buildings to be completed, the 16-story nurses' residence known as Fairbank, or East, Hall.

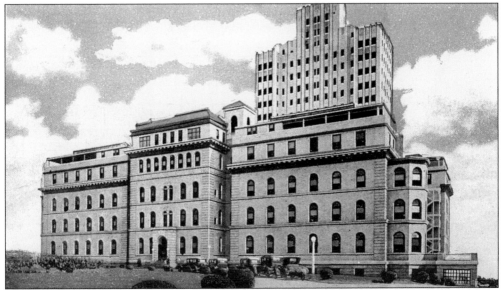

The newly completed surgical (Holloway) building rises high above the original 1909 hospital (front) and its 1919 addition. In 1934, the 1909 hospital was demolished. It was during this period that the hospital changed its name to the Jersey City Medical Center, as Mayor Frank Hague had plans that called for the construction of not only a new general hospital but also several buildings to house specialized medical services.

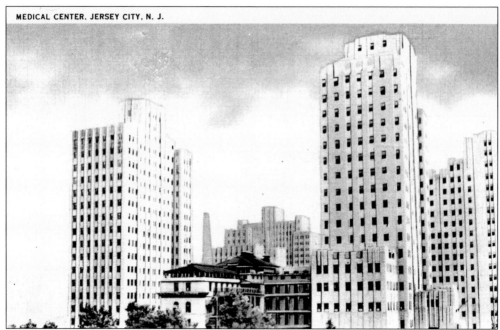

This c. 1940 view shows a completed medical building (A) and the health services, or clinic, building (B). When the surgical building (seen behind the 1919 addition to the 1909 hospital) was opened in 1931, it temporarily assumed many of the functions of the older general hospital. The original 1909 building was demolished in 1934 to make way for the new medical and clinic buildings. The 1919 addition remained for a few more years.

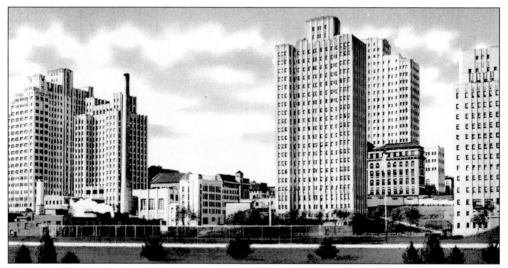

This c. 1940 image gives a good overall view of the various buildings on the hospital grounds at the time. On the far right is the staff residence, later known as Jones Hall and O'Hanlon Hall. In the center are the surgical building, the remaining half of the original hospital, and the new medical building in front. The smaller buildings to the left of the surgical building are nurses' residences. The smokestack to the power plant and laundry is clearly visible. Directly to the left of the smokestack is Fairbank Hall, a 16-story nurses' residence, with the Pollak Hospital immediately to its left.

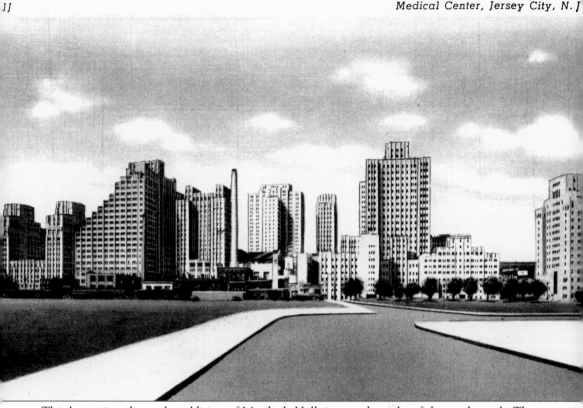

This later view shows the addition of Murdoch Hall, just to the right of the smokestack. The isolation building and Jones Hall are visible at the lower right. At the far left is the Margaret Hague Maternity Hospital.

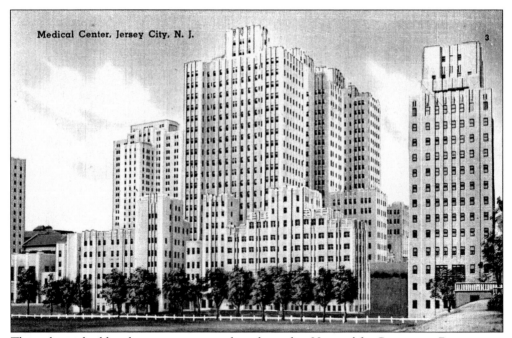

The isolation building became necessary when the earlier Hospital for Contagious Diseases was demolished in 1934. It is seen here directly in front of the surgical building. In later years, it was used as the Seton Hall Dental School.

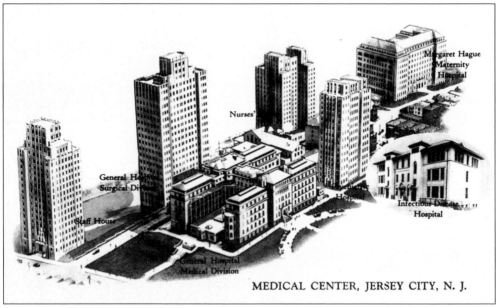

Pictured c. 1933 is the building that served as the Hospital for Contagious Diseases from 1931 to 1934, originally Public School No. 36, erected in 1918. In 1925, it became the A. Harry Moore School for Crippled Children. It was demolished in 1934 and replaced with a new isolation building.

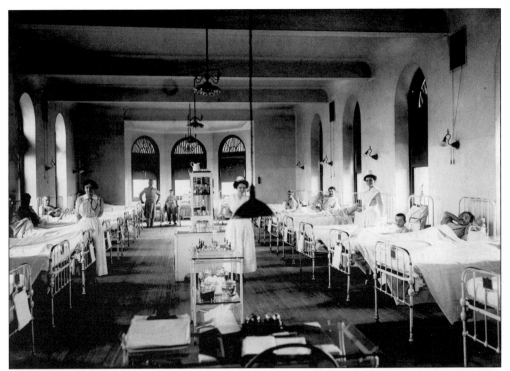

Most hospitalized patients, with the exception of the wealthy, were placed in wards. Wards were divided into male, female, and pediatric, with a further division into medical and surgical cases. This is the male medical ward at Jersey City Hospital in 1908.

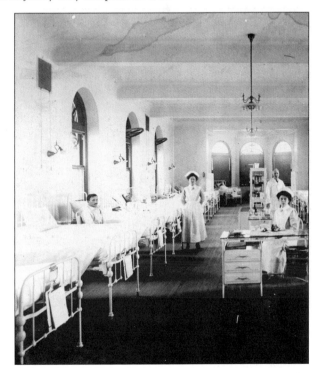

Both nurses and a house physician attended to the patients in the wards. Most patients did not have a personal physician, and with the exception of a traumatic injury, most sick patients who could afford it remained at home under the treatment of a private doctor.

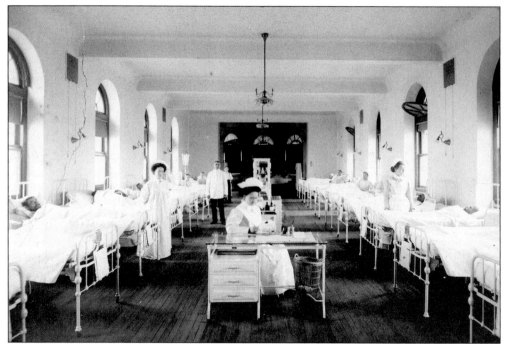

Shown is the male surgical ward in 1908. As evidenced by this filled-to-capacity ward, surgery—although not as sophisticated as today—was nonetheless practiced with some frequency.

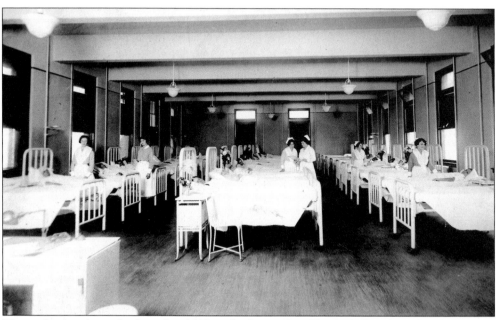

This is the female medical ward in 1920 at the Jersey City Hospital. Female and male patients each had their own ward. Note that there is very little room in this ward for any additional beds, an indication that females were more inclined to seek medical care, or to be hospitalized, than were males. Also, female utilization of the hospital increased dramatically over a 10-year period.

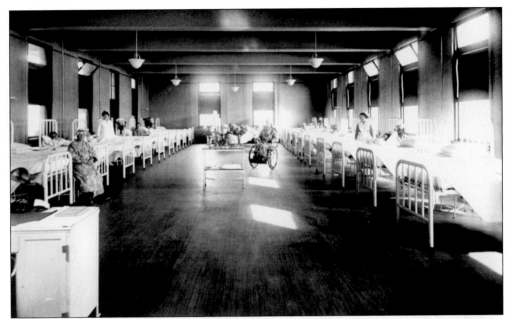

Obstetrical and gynecological patients were placed in wards reserved exclusively for such care. This ward was in the newer addition to the hospital, which was completed in 1919. This photograph was taken in 1921.

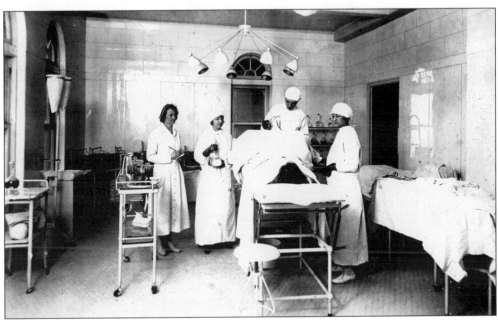

It was not until the 1930s that a separate hospital for the care of obstetrical patients was established in Jersey City. Until that time, gynecological and obstetrical care was carried out in the delivery room of the main hospital building, as seen here in 1921.

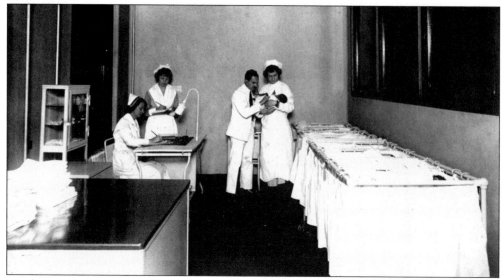

Newborn infants were cared for in the nursery. In this 1922 photograph, a line of bassinets can be seen, with the familiar observation window for those proud new fathers to see their offspring.

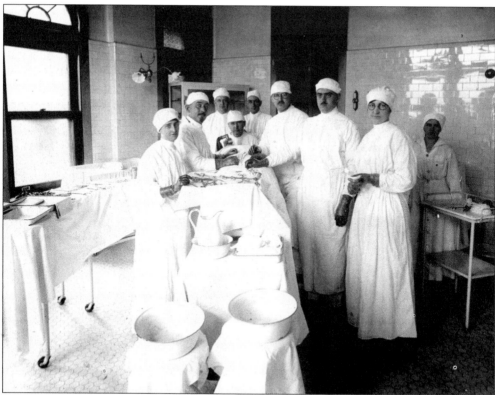

Although far from the high-tech sophistication of an operating room of today, this room was state of the art for its time, in 1917. The use of gloves on the surgeons as well as gowns may not seem that unusual, but it had been only 20 years earlier that aseptic surgical techniques began.

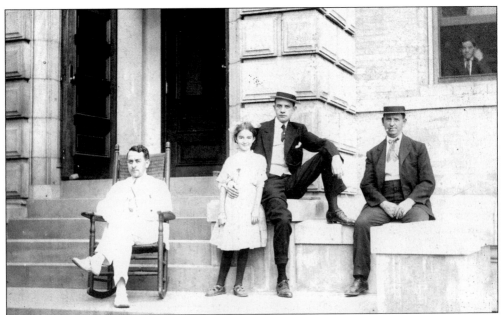

On March 1, 1908, Dr. Mortimer Lampson was appointed superintendent of the Jersey City Hospital. A graduate of the College of Physicians and Surgeons in New York City, he was the first physician selected for the post. He later became the plaintiff in a lawsuit against Jersey City and its mayor regarding which department—the board of health, of which Lampson was chairman, or the hospital's board of trustees—had the power to purchase land and erect buildings for a new hospital in Jersey City. This c. 1900 photograph shows Lampson, a staff physician and medical director at the time, in front of the hospital with his daughter. It is quite probable that Lampson resided at the hospital with his family.

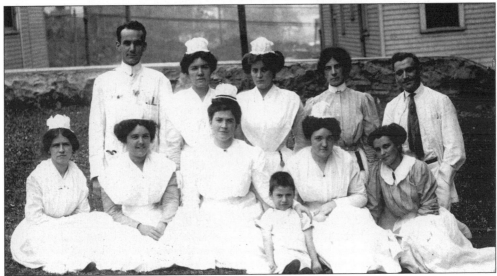

Interns and nurses pose in 1911 outside the hospital. In 1907, the hospital started a nursing school. Its students provided free labor in the wards while getting a good clinical education. In the early part of the 1900s, the hospital's entire house medical staff consisted of six interns. Only 50 percent of the doctors of this era served internships.

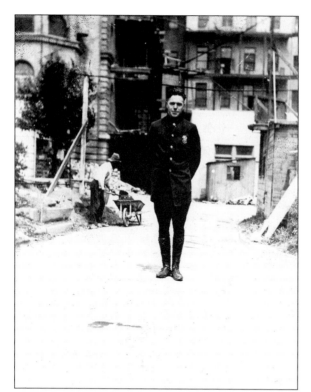

A police officer serving as an ambulance driver poses in back of the hospital c. 1900. Construction of the second large hospital building can be seen in the background.

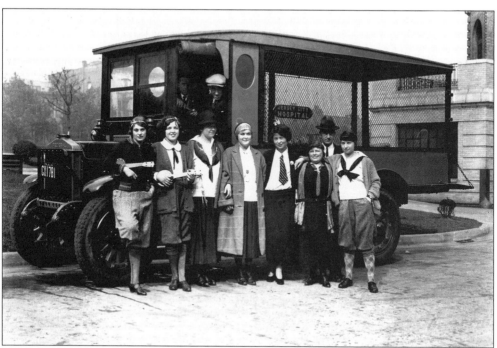

This c. 1920 photograph was taken outside the hospital. The truck is perhaps an early ambulance or a utility truck, and the workers are not dressed in period outfits but are ready for trick-or-treating in their Halloween costumes, showing there was still time for a little fun.

# Two

# THE BUILDING OF THE
# MEDICAL MECCA

The Jersey City Medical Center included the general hospital, the Pollack Chest Diseases Hospital, Murdoch Hall, and the Margaret Hague Maternity Hospital. The buildings, which are from 15 to 23 stories high, stand on their 14-acre site. After completion in late 1941, the complex was the third-largest healthcare facility in the world.

John T. Rowland Jr. of Jersey City is often cited as the sole architect involved in the design of the complex; in fact, there were two architects. The Margaret Hague Maternity Hospital and Murdoch Hall were designed by Christian H. Ziegler. The general architect for the remaining buildings, with their Art Deco design and stepped setbacks on the upper floors, was Rowland. He designed most of the city's public schools and many of the major private and public buildings, including the Labor Bank building, the Jersey Journal building, the Public Service buildings, and 2600 Hudson Boulevard, where both he and Mayor Frank Hague resided.

The Margaret Hague Maternity Hospital is one of the most revered landmarks in Jersey City, having more than 350,000 babies of record born there. Proposed by Hague in 1921, the original 10-story neoclassical building was the first new structure of the complex. It officially opened on October 12, 1931. Two claims for the first baby born at the hospital appear in the press, one for Carmen J. Rullo of Bayonne, born on October 9, 1931, and the other for Hugh James Nevin of Jersey City, born on October 15, 1931.

To get the project started, Hague recruited the assistance of the members of the Hudson County Freeholders, especially Mary T. Norton, later a congresswoman from Jersey City. Built between 1928 and 1931, the maternity hospital took a $1.6 million bond issue to fund the construction. It later included an Eleanor Roosevelt Nursery, which was visited by its namesake.

The maternity hospital had accommodations for 400 mothers and babies. The building featured a stainless steel chandelier in the delivery room, brass handles, and a terrazzo floor. The public rooms on the first floor were done in aluminum and bronze. The building also had several penthouses and a movie theater on the top floor. For a number of years, the hospital was noted for its low maternal death rate.

The maternity hospital closed in 1979, and the city of Jersey City leased it for office space until 1995. A maternity facility at the Jersey City Medical Center Margaret Hague Pavilion was opened in 1981, with a stained-glass window of the Madonna and Child that had once graced the lobby of the maternity hospital.

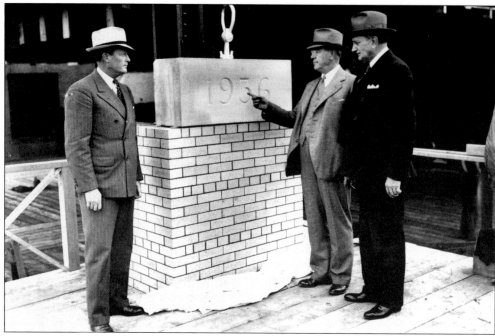

Architect John T. Rowland Jr. (1871–1945), who was responsible for the design of much of the Jersey City Medical Center, stands pointing to the cornerstone. He is flanked by Charles Wilson, deputy chief of police, and Daniel Casey, director of public safety. Rowland was the leading architect in Jersey City throughout the first four decades of the 20th century.

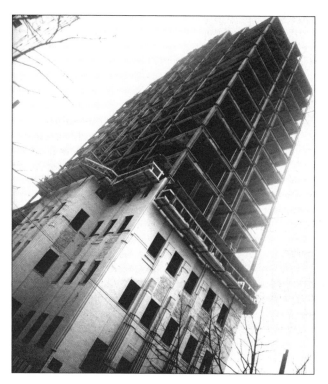

This 1937 photograph shows the clinic building under construction. With every building his administration erected on the hospital site, Mayor Frank Hague continued in the same pattern of building the largest and the best. He consolidated and enlarged the institution of the city hospital and, in 1931, changed the hospital's name to match his new concept: the Jersey City Medical Center.

Murdoch Hall, the last structure of the complex to be built, was the residence for graduate and student nurses. Constructed in 1941, the 17-story Art Deco building housed the School of Nursing and is named for Jessie M. Murdoch. Unlike most of the other buildings in the complex, Murdoch Hall was designed by Christian H. Ziegler rather than by John T. Rowland, whom he succeeded as the architect for the Jersey City Board of Education. Ziegler also designed the Margaret Hague Maternity Hospital.

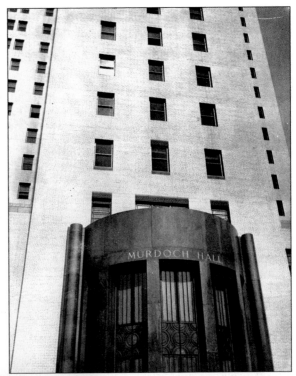

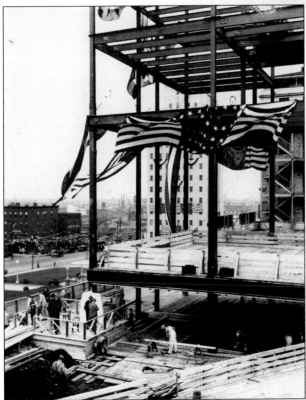

Construction of the medical building and the health services, or clinic, building followed Pollak Hospital. When the surgical building was opened in 1931, it temporarily assumed many of the functions of the older general hospital. The 1909 hospital was remodeled in 1919, remodernized in 1930, and demolished in 1934. The medical and clinic buildings that rose in its place are seen here, awaiting the arrival of Pres. Franklin D. Roosevelt, who dedicated them on October 2, 1936. The buildings were not completed until 1938.

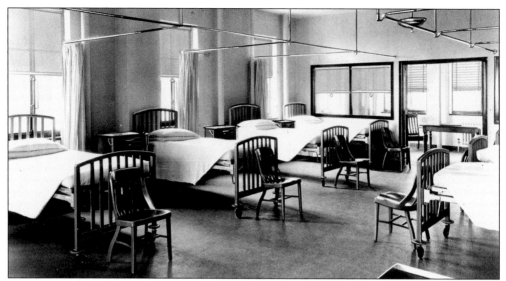

The new surgical building had 10 floors of typical wards. There were six floors of private rooms, which also had solariums on each floor. One floor housed a number of operating rooms. The remaining floors held doctors' lecture rooms, house surgeons' clinics, physical therapy rooms, and recreation rooms.

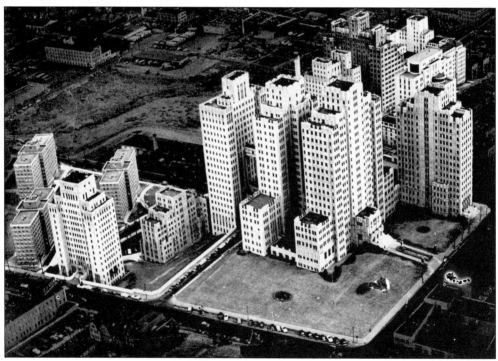

The complex eventually consisted of 10 major high-rise buildings with a number of auxiliary facilities. Most of the buildings are laid out on an approximately east–west axis, with the main entrance to the complex facing Baldwin Avenue to the west. The complex affords a broad prospect of Manhattan. The combination of building height and prominent setting makes the hospital one of the most important visual landmarks in Jersey City.

Most of the construction for the hospital was supported by municipal bonds and by loans and grants from the Public Works Administration, a division of the federal Works Progress Administration (as the large lawn sign indicates). In the 1936 election, Pres. Franklin D. Roosevelt won Hudson County by a margin of 117,000 votes, while New Jersey as a whole went Democratic by only 30,000 votes. Mayor Frank Hague was subsequently made vice chairman of the Democratic National Committee.

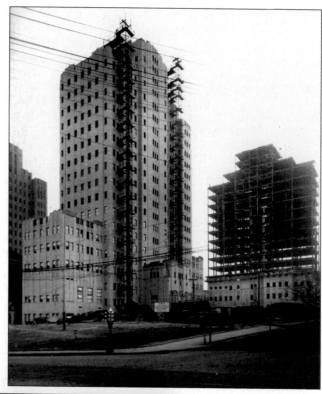

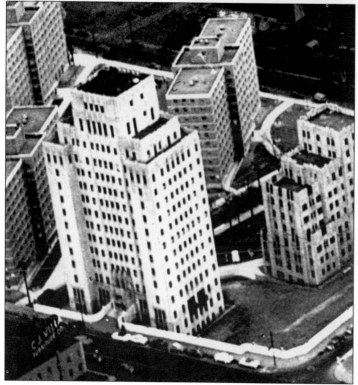

The staff house, seen here facing Mongomery Street, had various names over the years, including O'Hanlon Hall, Jones Hall, and Blozus Hall. It stood 15 stories and had 84 rooms for interns and residents, along with a number of small suites for the permanent staff physicians. It also contained a gymnasium, consultation and study rooms, and a dining room. The building was completed by 1932. It has since been converted to senior citizen housing.

This 1954 view of the penthouse dining room in Jones Hall reveals the detail work of the molding, as well as its own fireplace. Dr. George O'Hanlon occupied the penthouse during this time. Dr. Edgar Burke, resident surgeon, and Dr. Berthold Pollak, the head of the tuberculosis hospital, occupied other penthouse apartments in other buildings on the campus.

It is said that the Jersey City Medical Center's live-in quarters were "the equal of any rich man's club." The penthouse of Jones Hall served as the living quarters of the medical director, George O'Hanlon, in addition to his $12,000 annual salary and his living expenses. The penthouse was large and had solid wood paneling in many of the rooms. The penthouse living room also had a working fireplace.

Sunshine is the only visitor to this barren solarium atop O'Hanlon Hall in 1954.

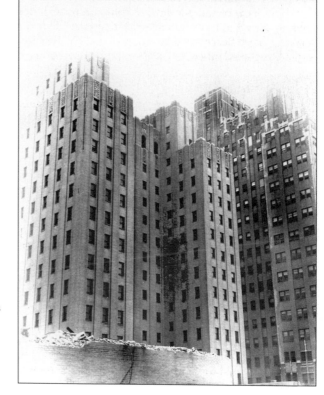

The Great Depression forced a halt to construction in 1933, but in 1934, a second round began with the construction of the Hudson County Tuberculosis Hospital, which was completed in 1936. In 1947, this hospital was renamed the Berthold S. Pollak Hospital for Chest Diseases to honor one of the institution's best-known doctors.

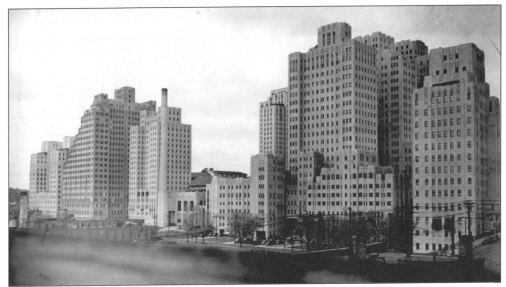

Despite its architectural splendor, the facility was simply larger than was required for the healthcare needs of the citizens of Jersey City and Hudson County. Even when civic pride in the construction of the massive hospital complex was unbridled, there were critics who argued that the cost of operating and maintaining the complex would eventually cause the city dire financial harm. Indeed, the facility has never used all of its space for municipal hospital purposes, and the prophecies of the critics proved all too true.

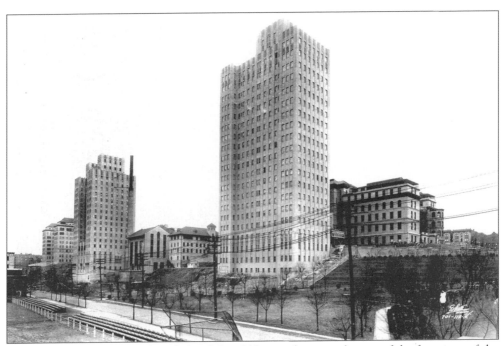

The surgical building, seen here behind the old hospital, assumed many of the functions of the older general hospital.

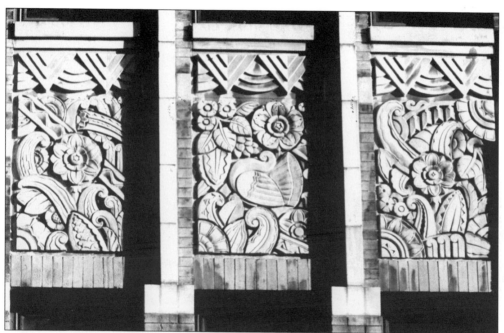

The typical design vocabulary of Art Deco is
used abundantly in the hospital buildings,
with stylized foliage and animal forms.

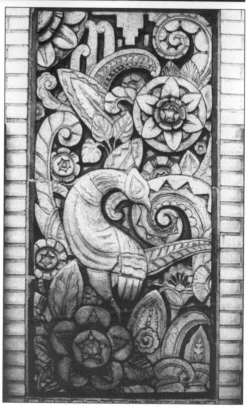

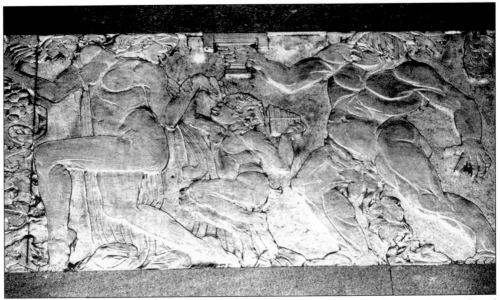

Many of the very elaborate stylized engravings, as seen in the following photographs, are found on the exterior terra-cotta panels and architraves in the interior public spaces.

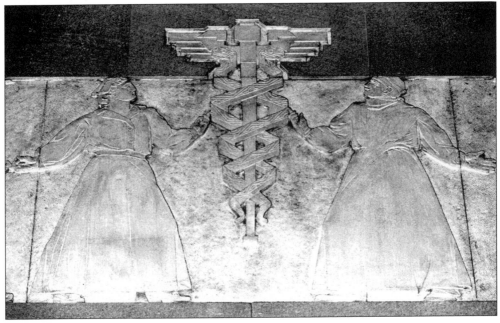

During the years the style was in fashion, the term Art Deco was not known. Instead, it was Modernistic or Style Moderne. The term Art Deco was coined in the 1960s by Bevis Hillier, a British art critic and historian. Its name is derived from the 1925 Exposition Internationale des Arts Decoratifs Industriels et Modernes, held in Paris.

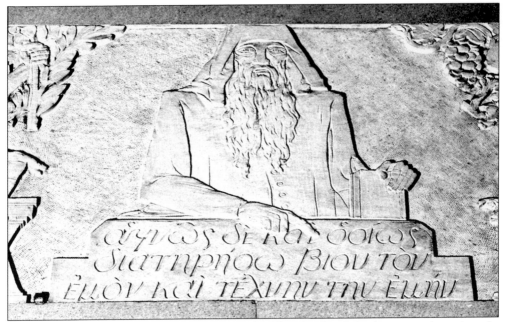

In this detailed carving from inside the hospital lobby, the Greek (in basic translation) reads, "In a manner holy and pious I shall watch over my life and my craft."

Although Art Deco looks ultramodern, it actually dates back to the days of Egyptian tombs. Specifically, the discovery of King Tut's tomb, in the 1920s, opened the door to this enticing style.

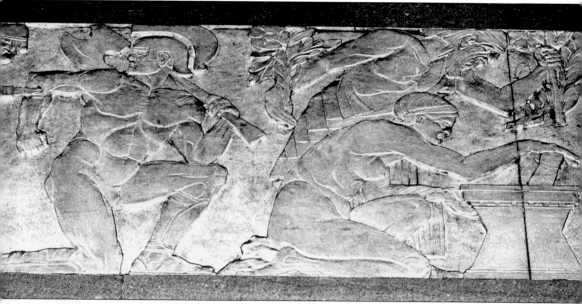

Stark lines, bold colors, and zigzag architectural features were added to objects placed in the tomb to entertain and enlighten the sleeping kings. This style greatly appealed to Americans, who were going through the Roaring Twenties and loved the eclectic look. They saw it as a symbol of decadence and extravagance, qualities their generation embraced. The bold colors and sharp lines of the movement all heavily influenced art, architecture, jewelry, and fashion.

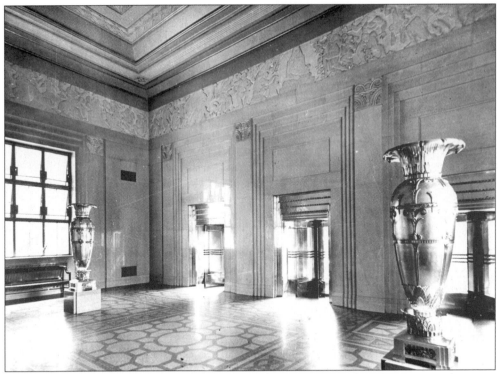

By the 1930s, some hospital administrators were beginning to realize that a patient's proper mental attitude was hardly possible in the older hospitals that resembled correctional institutions. Thus, the interiors were changed—sometimes quite lavishly, as seen here in the lobby of the main hospital building and in the corridors between buildings.

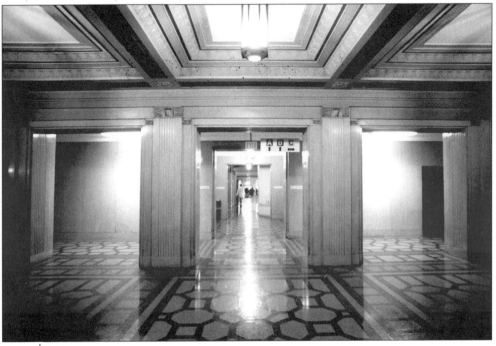

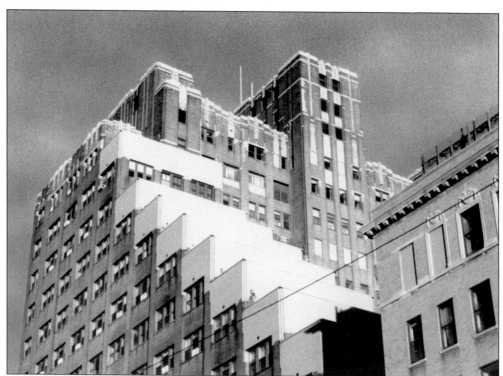

The most obvious large-scale Art Deco feature of the Jersey City Medical Center is the use of stepped setbacks, found most dramatically in the Pollak Hospital. Stylistically, this feature can be traced to the ziggurat temples of pre-Columbian Central America, a culture that influenced the design vocabulary of American Art Deco.

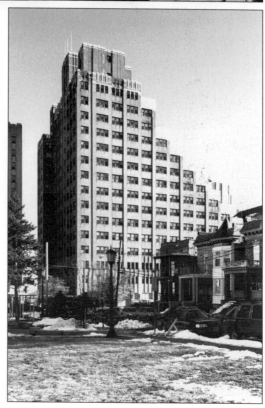

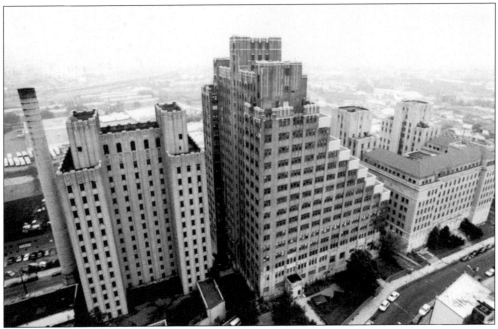

The stepped setbacks are visually pleasing in this view of the Pollak Hospital, with the Margaret Hague to the right and Fairbank Hall to the left.

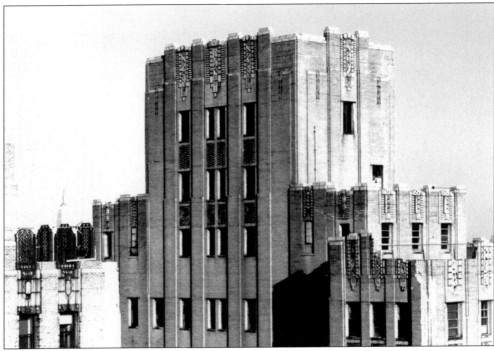

In contrast to the frequently lavish interiors, the exteriors of most high-rise Art Deco buildings are decorated sparely, with ornament concentrated at the bottom four to six stories where it can make a strong impression on pedestrians, and at the top, where large-scale decorative features read clearly from a distance.

44

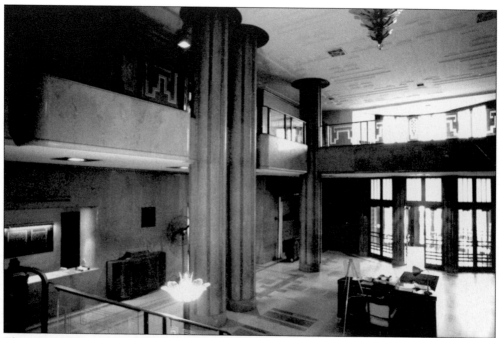

The main lobby of Murdoch Hall is very sophisticated in its décor, deriving its effect mainly from the quality of materials used and the manipulation of light and space. Murdock Hall was the dormitory of the school of nursing, which trained young women from across the United States and other countries to be nurses.

The interior of Murdoch Hall is such a magnificent example of Art Deco architecture that it was the set for much of the movie *Quiz Show*. Most viewers thought that the interiors they saw in that film were in the Rockefeller Center television studios of the early television networks that broadcast the shows. Those interiors were Murdock Hall.

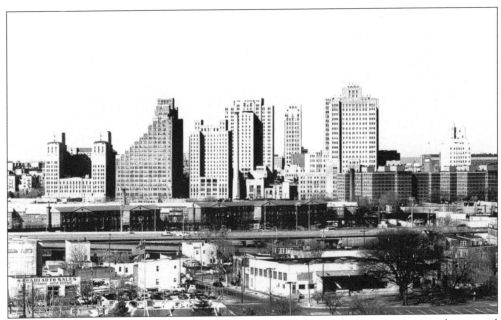

The soaring shafts of the Art Deco buildings, which are unified in appearance by several elements such as the buff brick with terra-cotta and metal trim, stand out against the sky in dramatic outline.

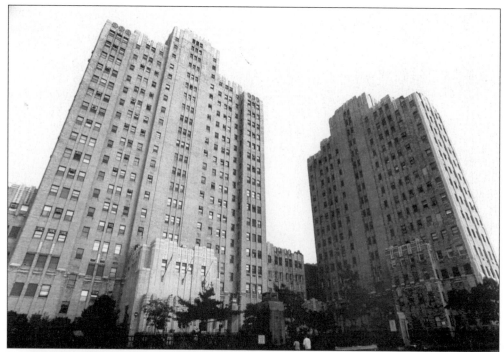

From the street, the Art Deco buildings provide the center's major visual impact, with buildings A and B dominating the streetscape on Baldwin Avenue. A broad lawn and the remnants of the water and garden feature proclaim that this is the entrance to the complex.

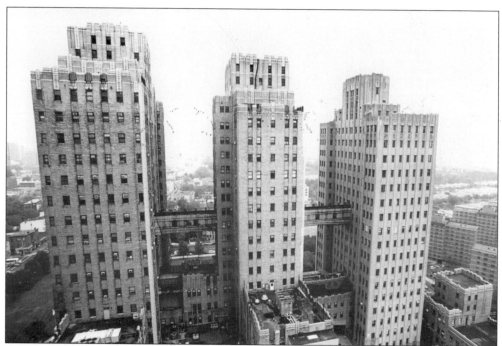

Seen in a view looking north from atop Murdoch Hall, the Art Deco buildings dominate, with their relationship to each other reinforced by the physical linkage of wings and bridges.

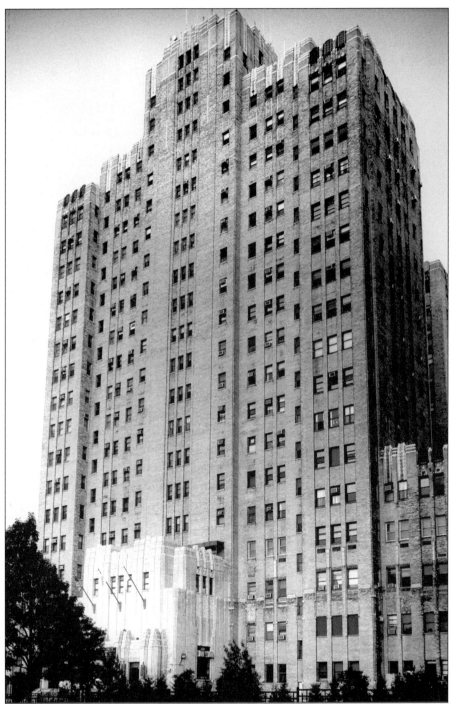

Building A, known as the medical building, is the principal entrance and lobby to the entire complex. It varies in height from 5 to 22 floors with a high basement, and it comprises seven rectangular or nearly square blocks so disposed that they produce a seven-bay facade of projecting and receding planes. The 22-story center block is flanked by three unequally stepped wings at either side and fronted by a 3-story entrance pavilion of three bays.

48

The pavilion is reached by a walkway that is edged with a low, gray polished granite retaining wall and is divided into two sections by a planter reflecting pool, emphasizing the importance of the principal entry.

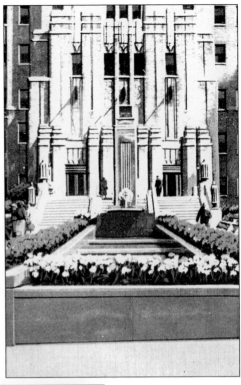

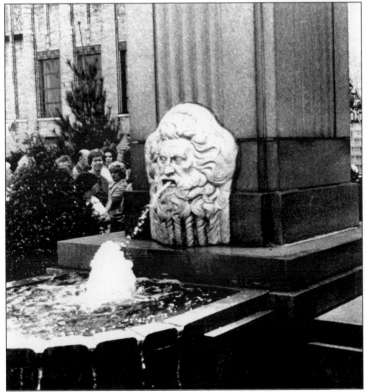

The pool is terminated by a 15-foot stone column that is adorned with a brass Graecoid mask.

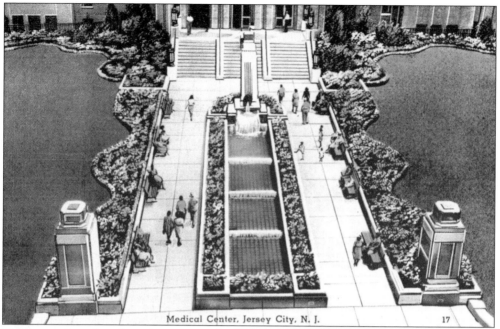

Medical Center, Jersey City, N. J.                    17

These two views show how the water used to flow from the beautiful Poseidon in the reflecting pool. Also seen is the lush lawn from days gone by.

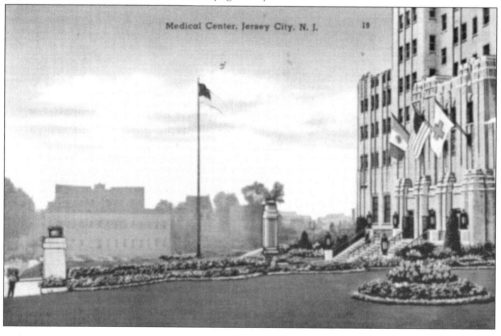

Medical Center, Jersey City, N. J.          19

The clinic building, which served as the School of Medicine, is seen with the beautifully manicured lawn.

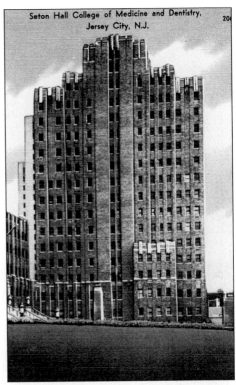

Seton Hall College of Medicine and Dentistry, Jersey City, N.J.

20

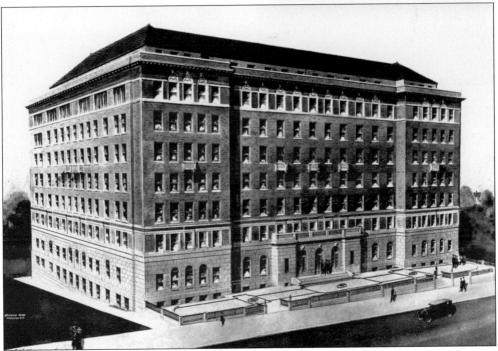

The first building of the present Jersey City Medical Center was the Margaret Hague Maternity Hospital, shown here in an artist's rendering. Its construction was started in 1928 and was completed in 1931.

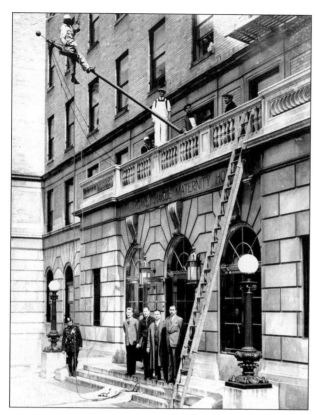

By the late 1920s, the most pressing immediate problem was the shortage and inconvenience of maternity care facilities. The answer that Mayor Frank Hague's administration came up with was to build the world's largest maternity hospital. It was begun in 1928 and completed in 1931. Here, some touch-up work is done on the balcony.

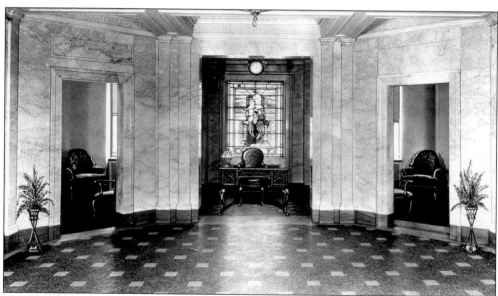

The maternity hospital closed in 1979, and the city leased it for office space until 1995. Today, the Hudson County Improvement Authority owns it. A maternity facility was opened at the Jersey City Medical Center Margaret Hague Pavilion in 1981, and a stained-glass window of the Madonna and Child was moved from the closed maternity hospital lobby, shown here, to the pavilion.

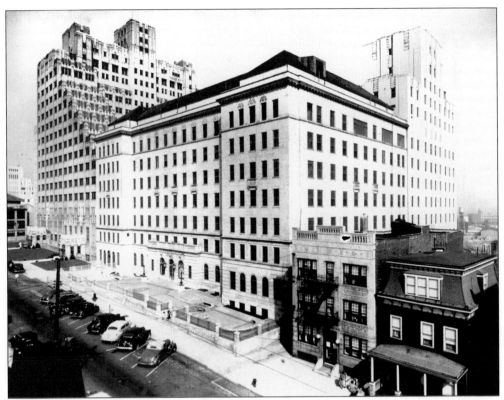

This *c.* 1940s photograph shows the Margaret Hague Maternity Hospital, the first maternity hospital in the country, begun in 1931. Several important obstetrical and gynecological procedures were pioneered at this hospital, which coined the term low-birthweight baby. Physicians throughout the country continue to esteem the research contributions of the hospital.

Among the medical procedures developed at the Margaret Hague was the Waters' extraperitoneal cesarean section, used by physicians for mothers who had infections inside the uterus before delivery. The procedure enabled the physician to perform the operative delivery of the baby without exposing the area of infection to the mother's abdominal cavity. (Due to the development of antibiotics, this procedure is no longer performed today.) The hospital also boasted the lowest mortality rate of any maternity hospital in the world, mainly attributable to its outstanding medical staff.

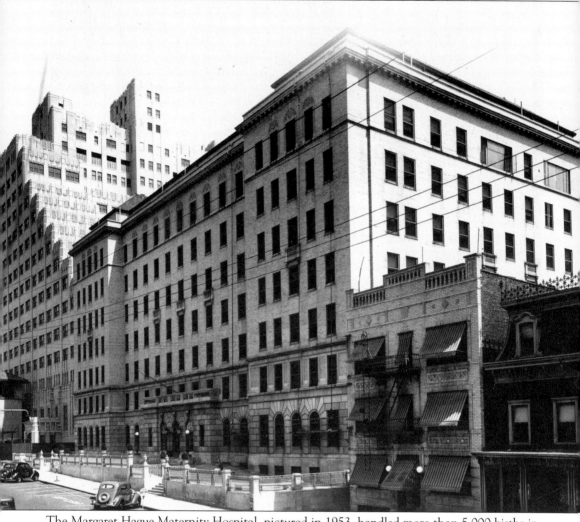

The Margaret Hague Maternity Hospital, pictured in 1953, handled more than 5,000 births in 1939, more by several hundred than any other hospital in the continental United States. Estimates on the number of deliveries performed at the hospital between 1931 and its closing in 1975 range from 100,000 to over 300,000, depending on the source.

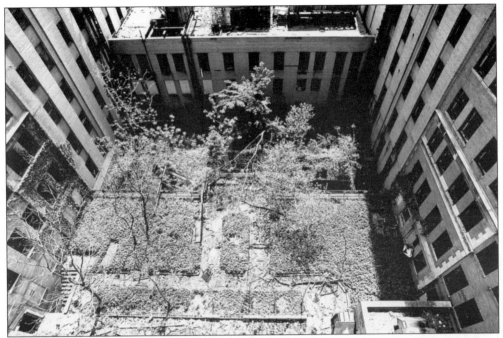

The Margaret Hague Maternity Hospital was originally a U-shaped building with a courtyard and playground in the middle. Note the slide in the upper left corner.

An Art Deco extension was build at the back of the Margaret Hague Maternity Hospital in 1940.

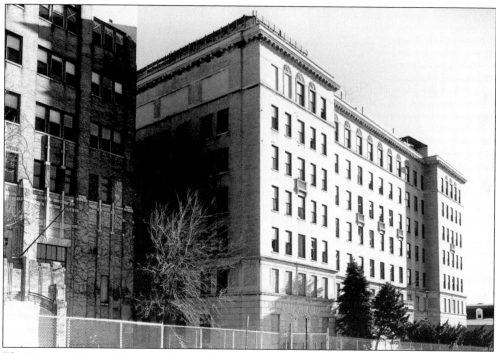

The Margaret Hague Maternity Hospital was named in memory of former mayor Frank Hague's mother. The state-of-the-art maternity hospital was erected on Clifton Place at Fairmount Avenue between 1928 and 1931.

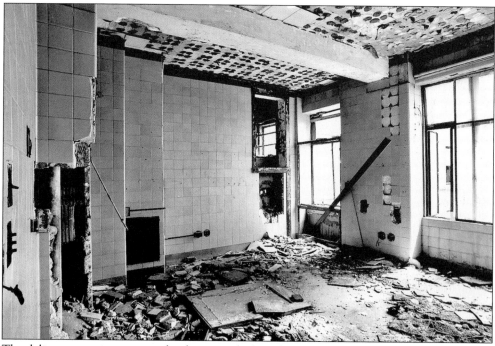

The delivery room is now completely stripped of its electrical wiring and plumbing fixtures.

The windows are blown out. The walls are ripped open and stripped of their copper. Hundreds of gurneys lie overturned and rusting.

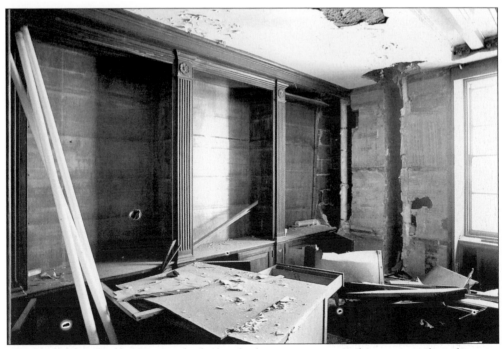

Abandoned for almost 30 years, the hospital where so many were born is a modern-day ruin. Except for a few remaining bookcases, this once beautiful library is now completely destroyed.

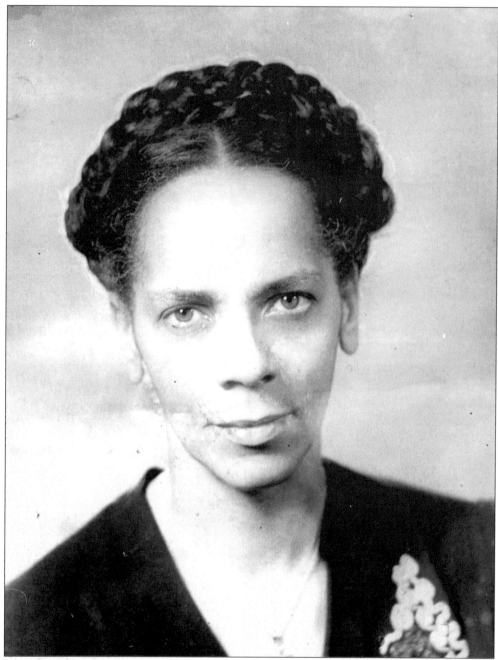

Dr. Lena Edwards graduated from Howard Medical School in Washington, D.C., the only female in her class. When she entered practice in Jersey City in the 1920s, the country had 65 black women physicians. In 1931, having previously attended most births at home, she became a staff member of the new Margaret Hague Maternity Hospital. After her application for residency was rejected several times in 1945, she was finally accepted at Margaret Hague. In 1946, she took and passed her national boards in obstetrics and gynecology and entered the annals of history as the second black women in the nation to be board certified in obstetrics and gynecology. (Courtesy of the Howard University Special Collections Department.)

The Margaret Hague Hospital served the entire Hudson County population. In the areas of staff and equipment, it benefited being close to the Jersey City Medical Center. Nonpaying patients received the same standard of care as those who were in the most expensive private rooms. The hospital was comprised of multiple rooms of four or eight beds, unlike the rows of beds seen in the typical ward, as well as two-bed semiprivate rooms, and private rooms for the wealthy. Charges varied from $3.50 a day for a ward patient to $192 a day for one of the private rooms, as seen in this c. 1930s photograph.

The miles of corridors in the Jersey City Medical Center buildings were paved with terrazzo and walled with tan marble, as requested by Mayor Frank Hague.

The tiled kitchen in the hospital was inspected by Hague himself for cleanliness.

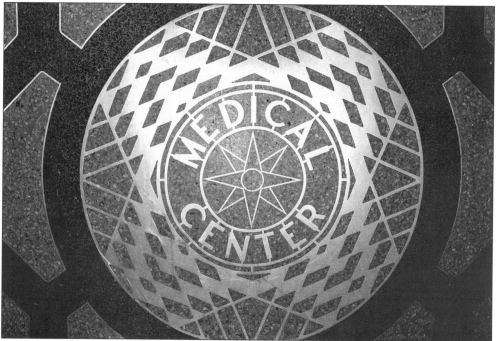

This floor medallion is at the entrance of the clinic building.

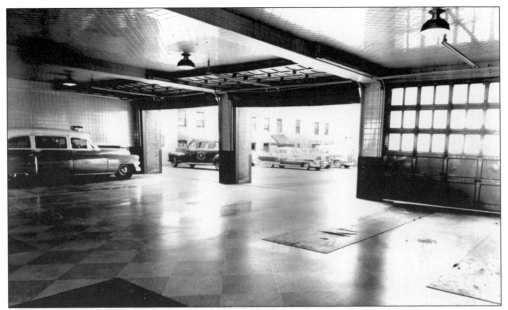

A new garage was needed to accommodate a greater number of ambulances. In this 1954 photograph, even the ambulances in the eight-story garage and storehouse building stood upon a floor of green-and-yellow terrazzo design while awaiting emergency calls.

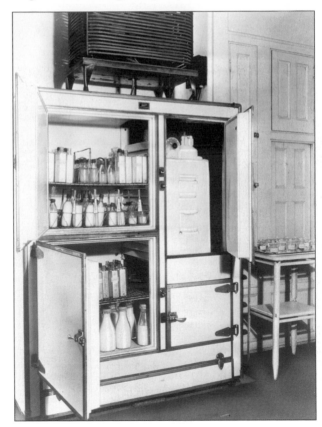

Although it looks like something from the stone age, this refrigerator (used to hold medicine as well as baby formula) was state-of-the-art equipment in the 1930s.

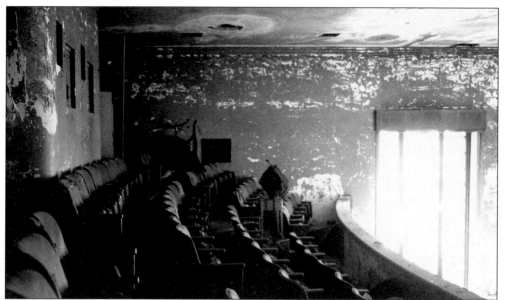

Several buildings in the complex ceased being used as medical facilities. Now vacant or underutilized, they have been allowed to deteriorate or have been severely vandalized, such as this theater in Murdoch Hall.

A 1931 souvenir brochure described the roof solarium as "a roof-garden for convalescents, 23 floors above street level, where patients on the recovery list could enjoy 'mountain-air' in the city." In addition to rooftop solariums, there was a rooftop playground, shown here.

All of the buildings of the medical complex are of steel skeleton construction, fireproof, and faced with buff-colored brick.

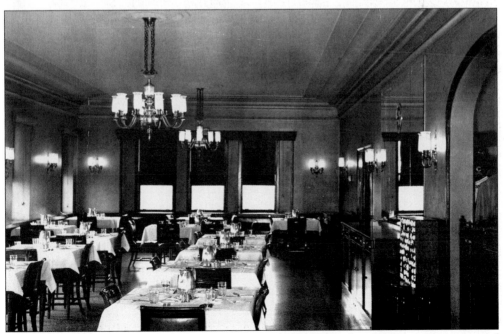

The staff house provided handsome suites in which physicians lived, libraries, lounges, and study rooms. Shown is a doctors' dining room. All of the medical staff received the very best food, which was prepared by a French chef, who was employed at a salary of $4,000 a year.

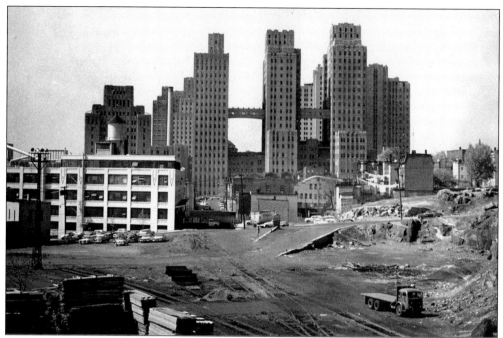

The total published cost of the New Jersey Medical Center buildings erected and land purchased during the Frank Hague administration is $21.9 million. This sum does not include the staff house or nurses' home, which cost an estimated $5 million more. Furnishings and equipment were purchased year by year. This overview was taken looking south in 1978.

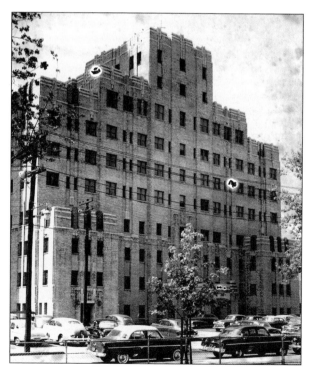

The isolation building became a necessity when the earlier Hospital for Contagious Diseases was demolished in 1934 to provide for a site for the new tuberculosis hospital. The building eventually became the home of the Seton Hall College of Dentistry.

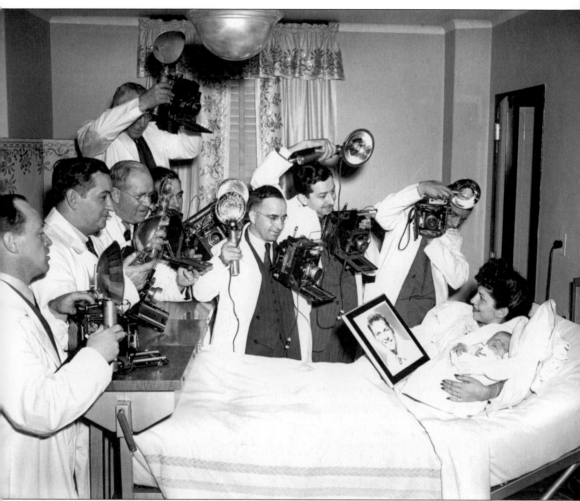

Among those born at the Margaret Hague Maternity Hospital is James McGreevey, the governor of New Jersey. Others born here include mayors, scientists, and celebrities. This January 11, 1944, photograph shows Mrs. Frank Sinatra holding a picture of her Frankie in one hand and her baby son, who was born the previous day, in the other. Photographers had to assume the garb of men in white when they photographed the son of "the Voice." Frankie Jr. tipped in at 8 pounds, 13 ounces while Frank Sinatra Sr. was in Hollywood making a movie.

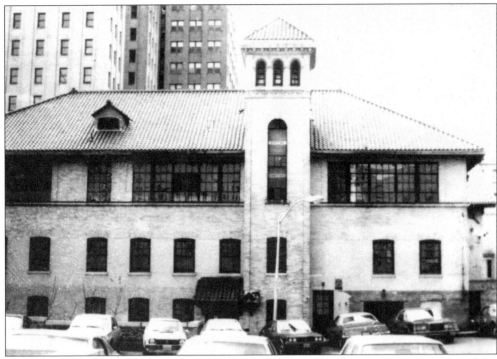

The early powerhouse-laundry structure was expanded c. 1920. This expansion continued the style, materials, and scale of the original powerhouse.

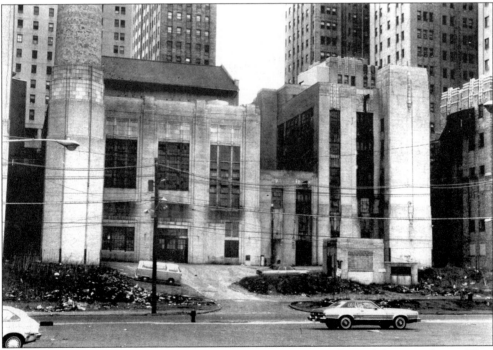

In 1924, the original powerhouse had two tall brick chimneys in front of the powerhouse. They were replaced by a single 20-story-high chimney in 1931, with the new addition.

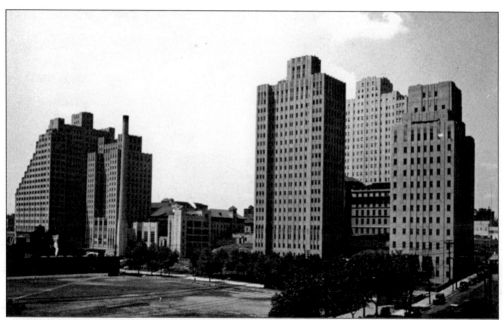

In 1931, the powerhouse (to the right of the smokestack) was extended down to Cornelison Avenue. The new style is Art Deco, with large windows and elaborate stone ornament.

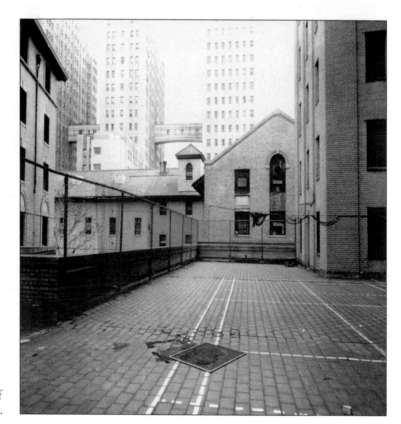

Vandalism after 1979 depleted the laundry building of metal and porcelain details and fixtures, and left almost all of the windows broken.

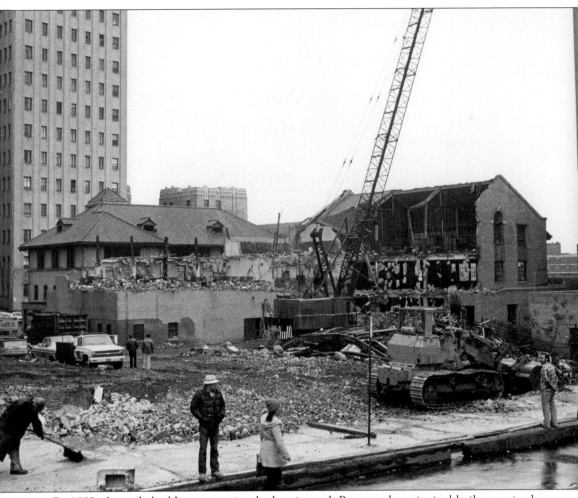

By 1982, the early building was seriously deteriorated. Because the principal boiler was in the 1931 addition, the earlier building was not needed. It was demolished in March 1982, and a much needed parking lot was put in its place.

# Three

# THE BOSS

## POLITICS AND THE MEDICAL CENTER

Frank Hague came from an Irish-immigrant area of Jersey City called the Horseshoe. Expelled from the sixth grade as a troublemaker, he never returned to school. He worked for two years as a blacksmith's helper at the Erie Railroad yards, the only private industry job he ever held. After he quit the railroad job, he managed a prizefighter before being recruited by a local Democrat to manage a "social club" in the Horseshoe. The social club was, in effect, a street gang that could be called upon during political campaigns to harass opponents and awe the electorate. At age 21, he ran for ward constable and won. Hague organized a political faction, offered support to the leader of the county machine, and effectively got out the vote in a sheriff's election. He and friends were subsequently appointed deputy sheriffs at a salary that was three times the average workman's wage.

In 1917, Hague became mayor of Jersey City, and by the 1920s, he had conceived the idea of a hospital that would dominate the Jersey City landscape for the next 50 years. He began not with the buildings but with the people, recruiting key staff from across the river in New York City. He renovated the original double-wing, six-story Jersey City Hospital building and erected a brand-new 23-story structure for surgical cases. The new facility opened in 1931, with Dr. George O'Hanlon as the first director.

On October 2, 1936, Hague declared a holiday in Jersey City, as 250,000 people gathered to watch Pres. Franklin D. Roosevelt dedicate the medical complex as it stands today—a symbolic gesture since the first building of the new complex, the Margaret Hague Maternity Hospital, opened in 1931, and the last, Murdoch Hall, was not completed until 1941.

With the assistance of the Works Progress Administration during the Great Depression, new buildings were added to the Jersey City Medical Center, and it became the pride of the mayor and the city. Free healthcare was provided to those residents who could not afford to pay. During the Hague years, it is said that the hospital cost $3 million to operate annually but brought in less than $1,500 in payments. By 1934, the complex had 750 employees and treated about 900 patients daily. (Portions from Jersey City Online, www.jerseycityonline.com.)

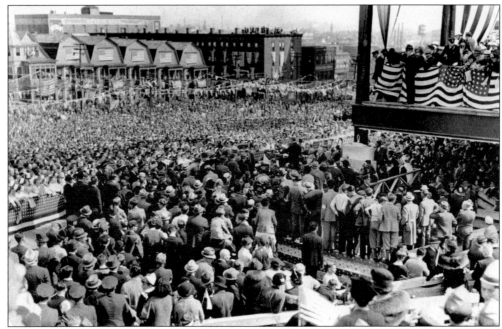

On December 6, 1934, groundbreaking was undertaken for the present medical and general hospital building. On October 2, 1936, Pres. Franklin D. Roosevelt laid the cornerstone of the new medical building at the Jersey City Medical Center. The day was declared a public holiday by the mayor, with all schools and public offices closed. Almost a quarter of a million people turned out for the ceremonies. The building received its first patients in 1938.

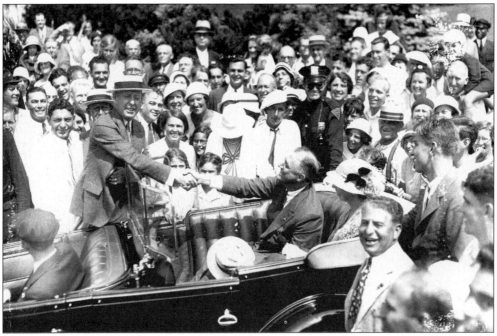

Mayor Frank Hague (left) greets Gov. Franklin D. Roosevelt of New York en route to Sea Girt for the great Democratic rally organized by Hague and attended by 100,000 persons.

Democratic presidential candidate Gov. Franklin D. Roosevelt of New York poses with Gov. A. Harry Moore of New Jersey (right) and Mayor Frank Hague just before mounting the speakers' stand to address the tens of thousands of supporters at Sea Girt for the launch of Roosevelt's eastern road campaign.

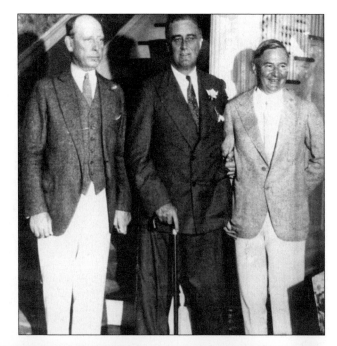

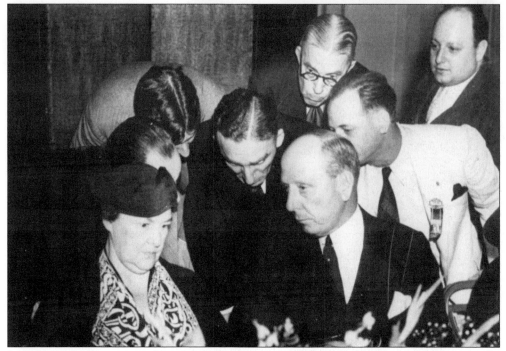

In 1923, Mary Norton was elected the first Democratic woman freeholder in New Jersey on the Hudson County Board of Freeholders. She successfully obtained board approval of the construction of a maternity hospital in Jersey City at county expense. Her interest in the hospital was that the infant mortality rate in Hudson County in 1923 was 212 per 1,000 births. Making use of Frank Hague's suggestion of a gradualist approach and his behind-the-scenes support, Norton got her proposal adopted.

It is said that Mayor Frank Hague conceived the idea of a maternity hospital in 1921. As this idea grew, Hague convinced Congressman Oscar L. Auf der Heide and Congresswoman Mary T. Norton, members of the Hudson County Board of Freeholders, to draft legislation that would allow the county to build the hospital. Norton (left), chairman of the House Labor Committee, confers with Rep. Carl Vinson (standing) and Rep. Howard D. Smith on November 24, 1941, at the opening of the hearings on strike legislation in Washington.

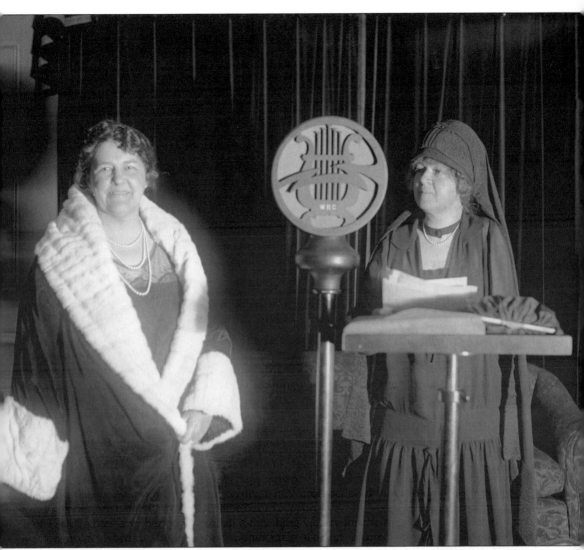

On March 27, 1926, station WRC, in Washington, D.C., carried the first radio debate by two women in Congress. Rep. Mary E. Norton of New Jersey (left) and Rep. Edith N. Rogers of Massachusetts are shown before the microphone at the debate. In 1924, with Frank Hague's encouragement, Norton became a candidate for the House of Representatives from the 12th Congressional District of New Jersey (Bayonne and Jersey City). The elections that year were slated to be a Republican sweep nationally, but Norton believed that the women she had met throughout the community would come out to support her. She won the election by a plurality of 17,000 votes over her opponent, an astonishing victory for the time, even in a Democratic stronghold. Norton was the first Democratic woman elected to the U.S. House of Representatives and the first woman to chair a major committee in Congress. Her finest hour may have been passage of the controversial Fair Labor Standards Act of 1938 while chair of the House Labor Committee. She was instrumental in raising the minimum wage from 40¢ to 75¢ per hour. She represented her district from 1925 to 1951, a total of 13 consecutive terms.

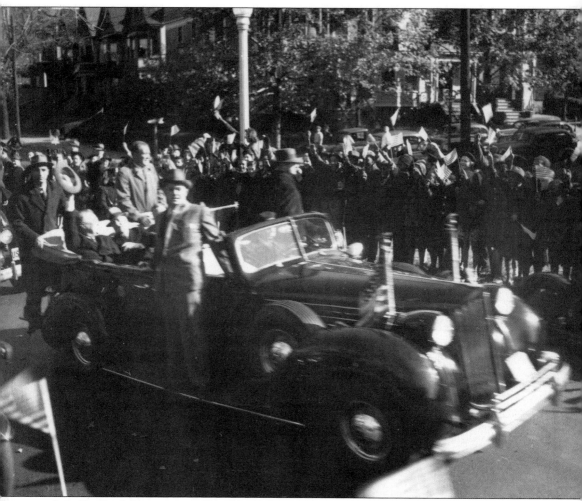

Initially, Frank Hague opposed Franklin D. Roosevelt's 1932 presidential nomination, but later, he became a close ally of Roosevelt. Here, Roosevelt's motorcade leaves the hospital at Montgomery and West Streets after the cornerstone ceremony in 1936. Immediately to the right of the president is John Malone, Hague's deputy mayor. Hague himself is obscured to the right of Malone.

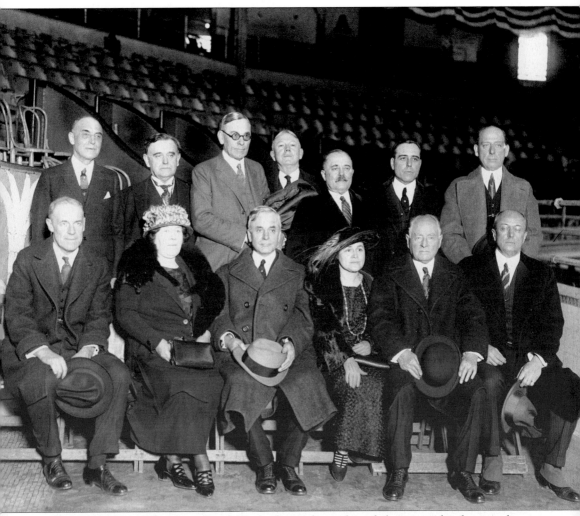

In this 1924 photograph, Mayor Frank Hague (second row, far right) poses with other members of the leadership of the National Democratic Committee in New York City. Hague was a very influential member of the National Democratic Committee, becoming vice chairman in 1936.

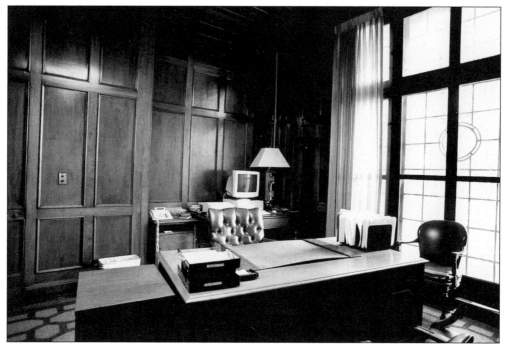

Mayor Frank Hague took an intense personal interest in the Jersey City Medical Center. At times he would spend a good part of his day there. He maintained an office at the hospital, and it was not unusual to see him walking the hospital halls or into a ward late at night. Although modernized with a computer and other state-of-the-art communication equipment, the office looks very much today as it did in Hague's era.

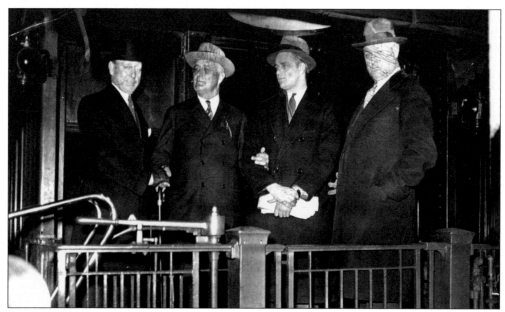

Frank Hague (far left) is seen on Franklin D. Roosevelt's campaign train as it makes a stop in Jersey City. With him are, from left to right, Franklin Roosevelt, son James Roosevelt, and James Farley, National Democratic chairman.

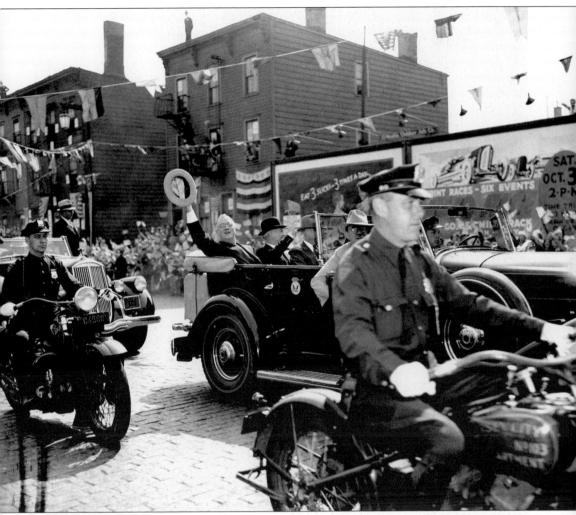

In this October 2, 1936, photograph, Pres. Franklin D. Roosevelt is seated in his automobile with Sen. A. Harry Moore of New Jersey. He acknowledges the cheers of the throng that line his path from the Holland Tunnel to the site of the Jersey City Medical Center. The president laid the cornerstone that day and then went on to attend the World Series.

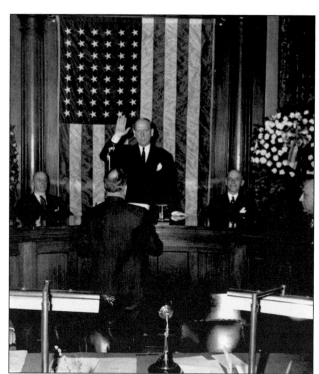

In the city council chamber in city hall, Mayor Frank Hague is sworn in for another term in 1945.

Christmas at the medical complex was always a special time. Without fail each Christmas, Mayor Frank Hague appeared in the children's ward with a lieutenant who was dressed as Santa Claus, bearing gifts for all. The nativity and Christmas tree were favorites.

Mayor Frank Hague gets ready to pull the ballot to vote for himself.

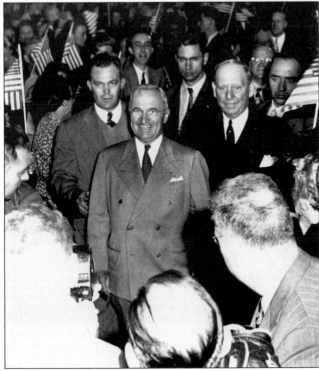

Following Franklin D. Roosevelt into the presidency was Harry Truman. Truman, too, relied on the vote-getting abilities of Frank Hague in his effort to upset Thomas Dewey and win the presidency in the election of 1948.

Arthur Harry Moore (July 3, 1879–November 18, 1952) began his political career in Jersey City and became the only three-term governor of New Jersey. He was elected governor for three nonconsecutive terms, in 1925, 1931, and 1937.

During Arthur Harry Moore's third term as governor, the state approved the pari-mutuel system of horse race betting and price controls on gasoline and liquor. In 1941, Moore retired from public life and resumed his law practice in Jersey City, where he lived on Arlington Avenue.

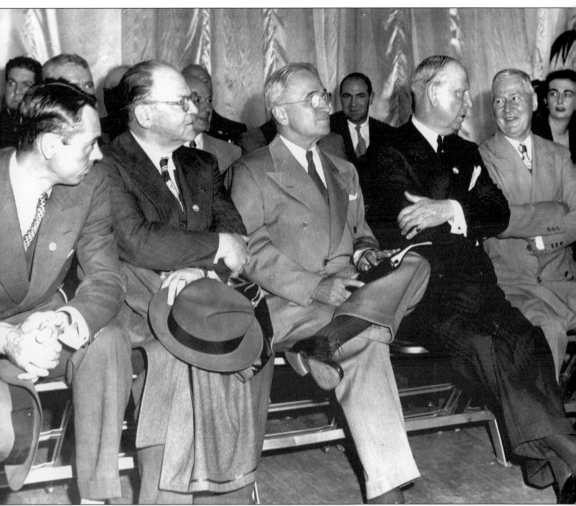

Frank Hague sits with Pres. Harry Truman, to his right, and speaks to Gov. Arthur Harry Moore, to his left. Moore was another influential part of the team helping to fund the Jersey City Medical Center. Elected a U.S. senator in 1934, he secured federal funding for the hospital and for other projects essential to improving the economy during the Great Depression.

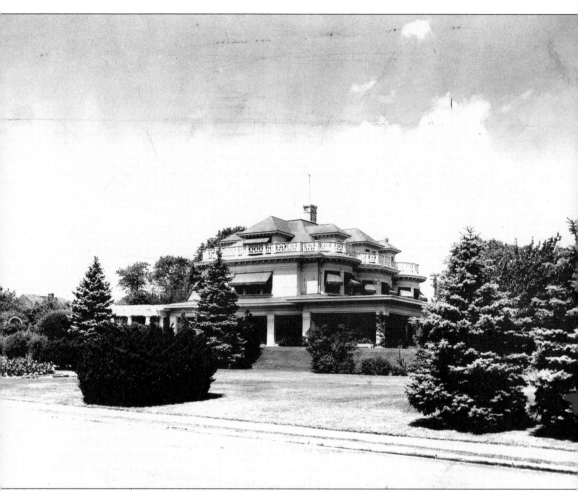

As mayor, Frank Hague earned a salary reportedly between $7,500 and $8,000 a year and lived in a 14-room duplex apartment on the ninth and tenth floors at 2600 Kennedy (then Hudson) Boulevard. The top-floor rooms offered a panoramic view east across the Hudson River, south to Bayonne, and west to Newark Bay. One main attraction on the ninth floor was a mahogany-paneled library. This is a photograph of Hague's mansion in Deal, said to have cost $125,720 in the 1930s, well over $1 million in today's value.

# Four
# NURSING EDUCATION

In 1907, under the auspices of the board of health and Dr. John Broderick, a training school for nurses was established at the Jersey City Hospital. Molly Southerland was named the school's first directress. She helped establish admission requirements, which called for applicants to be between the ages of 21 (later lowered to 18) and 32 and to have completed at least two years of high school.

On December 19, 1909, the first class of the school of nursing graduated in Hasbrouck Hall, a private school. The graduates were driven to the ceremony in the horse-and-buggy coaches used by the undertakers of Jersey City.

At first, classes for the students were held in the warden's house and conducted by the doctors. All classes were held at night. Students on night duty (which lasted for a period of six weeks without a day off) were read the doctors' lecture notes by an intern on the following day. The course on instruction included anatomy, physiology, chemistry, bacteriology, and materia medica. The practical aspect of the course was taught on the wards.

In 1914, Mayor Mark Fagan negotiated with architect John Rowland to building a nurses' home. The cost was $30,000. The building was eventually completed, and another was home added.

In 1922, Mayor Frank Hague secured the services of Jesse Murdoch, director of the Nurses' Training School at Post-Graduate Hospital in New York City. The hiring of Murdoch was an indication that the Jersey City Medical Center would emphasize nurses' training.

Born in Canada, Jessie McGavin Murdoch graduated from the Stratford General Hospital School of Nursing in Stratford, Ontario. From 1904 to 1912, she worked in the Panama Canal Zone as an assistant chief nurse during construction of the Panama Canal. In 1912, when she took over the program, the Jersey City Hospital Training School had 75 students and 25 graduates on staff. At this time the training program was increased to three years.

With the addition of Murdoch, the preclinical course was extended to four months, and the stipend was increased to $21 a month. The first semester, classes were given in anatomy and physiology, personal hygiene and sanitation, applied chemistry, nutrition and cookery, elementary materia medica, elementary nursing, hospital economics, bandaging and massage, ethics and nursing history, and physical training, which totaled 377 hours of classroom study. In 1923, Murdoch presided over her first graduation in her new school.

In July 1966, the Jersey City Medical Center School of Nursing graduated its last class.

In 1922, Frank Hague secured the services of Jesse Murdoch, director of the Nurses' Training School at Post-Graduate Hospital in New York City. This choice was an indication that the Jersey City Hospital would emphasize nurses' training. When Murdoch took over the program, it had 75 students and 25 graduates on staff; at this time the training program was increased to three years.

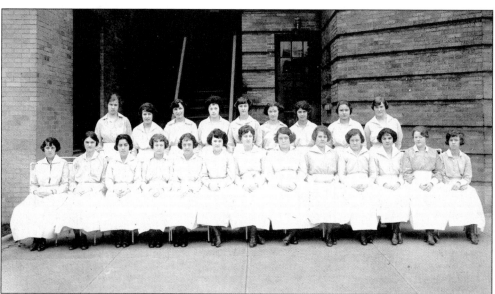

After a three-month probationary period, the students, called probationers, received their first caps. They were given three free hours before they were expected to report back to the wards with their new caps. In addition to the awarding of the cap, the bib could now be replaced by a kerchief. Prior to capping, the student received a stipend of $6 a month; this now increased to $8, and in the second full year, to $10.

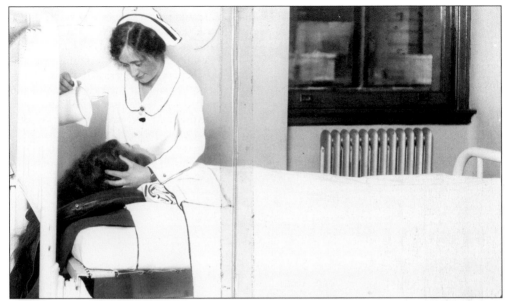

It is difficult to conceive of the circumstances under which these pioneer nurses labored. Aside from the cramped facilities, the treatments of the day were not always pleasant. Patients with back or kidney problems were subject to cane chair treatments, which consisted of bundling the patients up in a blankets and seating them in a cane chair over steaming tubs of water. The nurse would have to remain with the patient during the entire procedure to prevent any accidents from occurring.

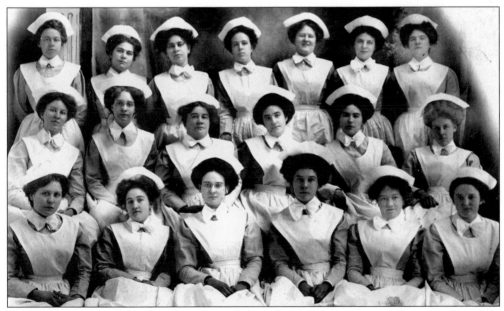

On December 19, 1909, the first class of the school of nursing, seen here, graduated in Hasbrouck Hall, a private school. The graduates were driven to the ceremony in the horse-and-buggy coaches used by the undertakers of Jersey City. The graduating class of 1909 received a waiver from the New Jersey State Board of Nursing, and all were licensed without examination. In 1913, the course of study was extended to two and a half years.

At the time the school was being formed, Margaret Muller, was awaiting word on her application to Lennox Hill Hospital in New York City, to which she had applied. Seeing the advertisement for the new school, she applied on December 5, 1907, and was in uniform by December 9 of that year, having the honor of being the first student to enter the newly formed program. By March 1908, the program had 19 students enrolled, 14 whom went on to graduate. Muller is seen here 50 years later.

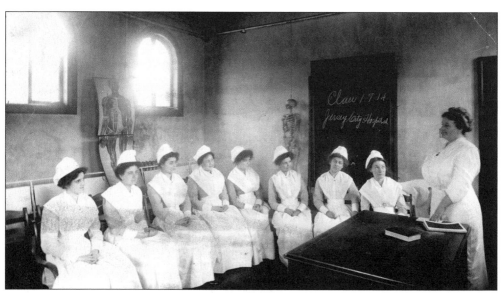

At first, classes for the students were held in the warden's house and conducted by the doctors. All classes were held at night. Students on night duty (which lasted for a period of six weeks without a day off) were read the doctors' lecture notes by an intern on the following day. The course of instruction included anatomy, as seen in this 1914 photograph, physiology, chemistry, bacteriology, and materia medica. The practical aspect of the course was taught on the wards.

With the opening of the nursing school in 1907, the demand for classroom space and living quarters grew rapidly. In 1914, Mayor Mark Fagan negotiated with architect John Rowland to building a nurses' home. The cost was $30,000.

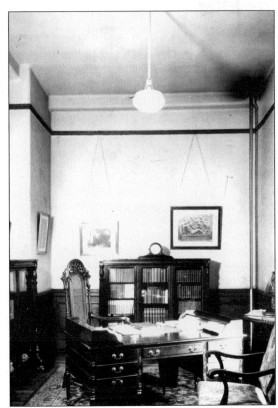

This photograph shows the interior of Jesse Murdoch's office, inside the first nurses' residence.

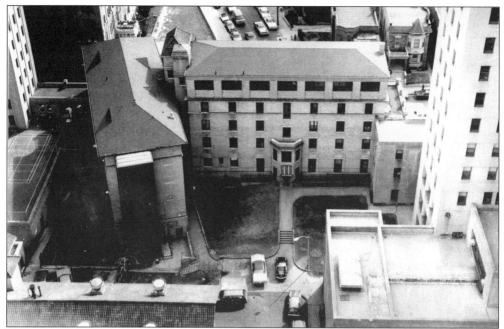

In 1919, construction of a second nurses' residence was begun. Eventually, the second unit was connected by a tunnel to Fairbank Hall, a 16-story nurses' residence.

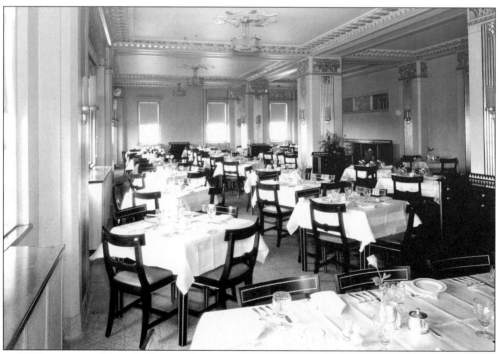

In 1932, a new residence hall opened. It was one of the finest in the country. It had classrooms on the lower floors, a science laboratory, a chemistry laboratory, a library, and an amphitheater. Accommodations were provided for 400 graduate and student nurses in the dining room, and special care was given to the décor.

A fireproof residence, the new nurses' home was 17 stories. A total of 350 small single-bed rooms were available for graduate and student nurses serving the Jersey City Medical Center.

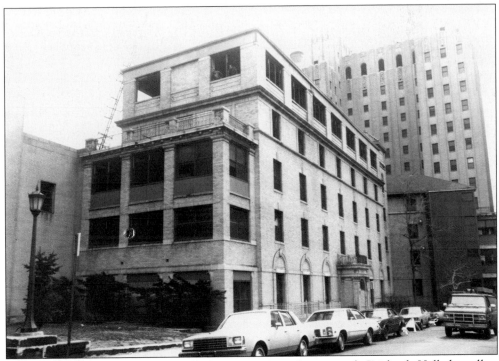

This *c.* 1960s photograph shows all three nurses' residences, with Fairbank Hall the tallest structure in the background.

Both of the original nurses' residence structures fell victim to vandalism.

As the vandalism became rampant, the buildings were stripped of their copper and porcelain. The vandalism, the city's inability to financially maintain the structures, and the shortage of on-site parking all led to the buildings' eventual demolition.

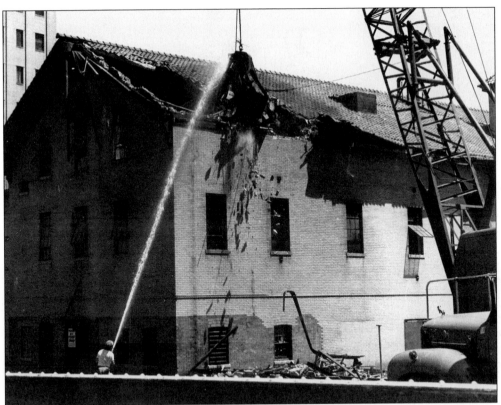

In the late 1970s, the nurses' residences were demolished, along with the laundry and old powerhouse. A new on-site parking facility was established on the site where these buildings once stood. The newest nursing home, Fairbank Hall, remains standing.

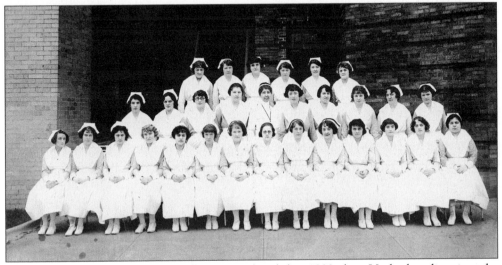

Jesse Murdoch (second row, center) is pictured with her 1923 class. Under her direction, the educational program became more orderly and inclusive. In 1926, the preclinical course was extended to four months, and the stipend was increased to $21 a month.

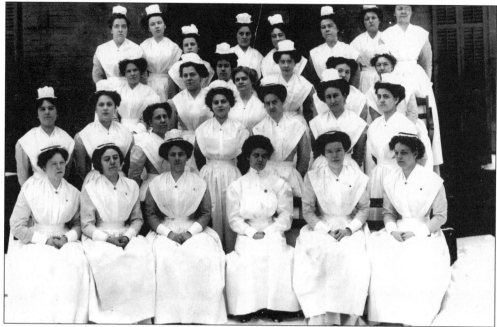

The uniforms being worn here by the graduates of 1910, 1911, and 1913, were either made by the students or purchased. They were of blue chambray with long sleeves, a long-waisted bodice, and buttons down the front to four inches below the waist. The uniform included a white Buster Brown collar, cuffs, a white linen tie, a white bib that came only to the shoulder blades and was fastened with two buttons, and a full, white muslin apron reaching almost to the black shoes. One wonders how comfortable such uniforms were.

This 1925 photograph shows the administrative staff and the nursing supervisors. They made weekly "dirt rounds," carrying with them cotton balls, which were used to check for dust and dirt. If dirt was found, there would be no time off for one week. Students were supposed to be excused for two hours during the day, but this rarely happened. A half-day was granted once a week.

In the years 1935 and 1936, the barriers came down. In 1935, 11 male students were admitted to the nursing school, and in 1936, a black student was accepted. Judging by this photograph taken two decades later, however, black students were still a rarity in the 1950s.

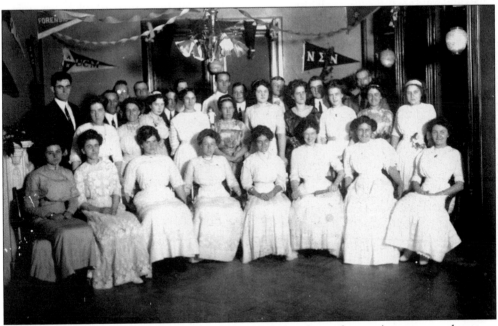

From the day the student entered training, she (only females at the time) went to work on one of the wards. Three weeks after donning her new uniform, it was not uncommon for a student to be placed in charge of the obstetric ward for a 12-hour tour of duty. There was still time for occasional fun, as seen in this photograph of a social event known as a hoedown.

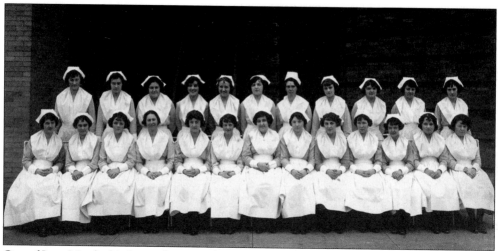

One of Jesse Murdoch's first tasks was to handle the admission of new students who formed the class of 1925, seen in this photograph. Then, she undertook the arduous and tiresome task of putting all of the records in order. The school had grown with such rapidity in its first 15 years that the heavy workload that fell on early administrators did not leave much time for the establishment of an elaborate system for student records. Murdoch compiled an extensive permanent dossier on each of the students and inaugurated a syllabus for study, as well as a plan for cultural activities.

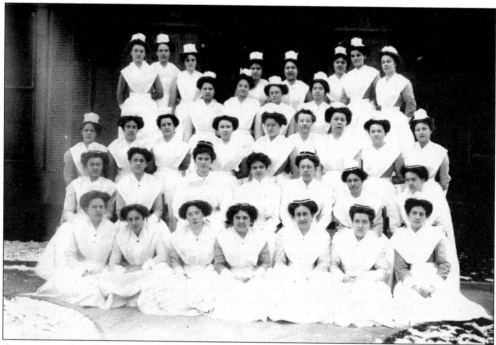

As seen in the class photographs that follow, the number of students remained relatively constant throughout the years, with each class numbering around 30 students.

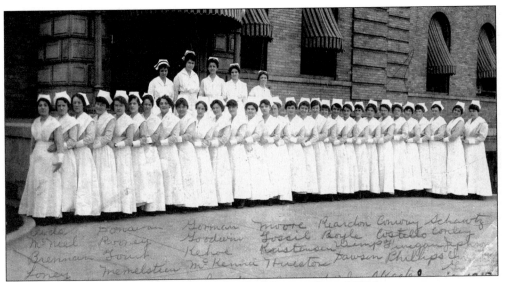

Shown here is the Jersey City Hospital School of Nursing class of 1915.

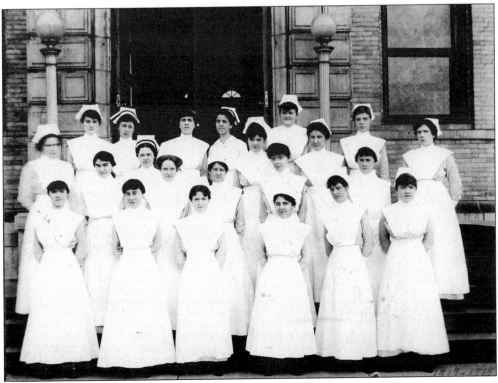

Pictured is the Jersey City Hospital School of Nursing class of 1918.

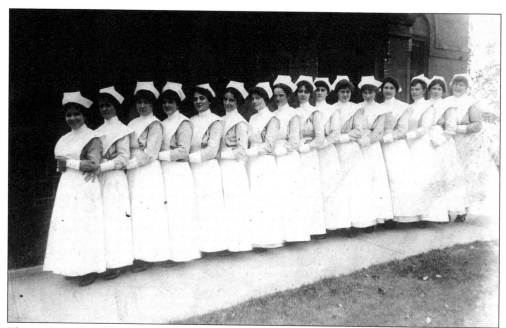

This is the Jersey City Hospital School of Nursing class of 1917.

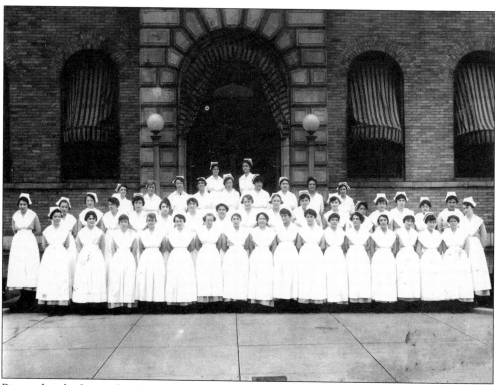

Pictured is the Jersey City Hospital School of Nursing class of 1920.

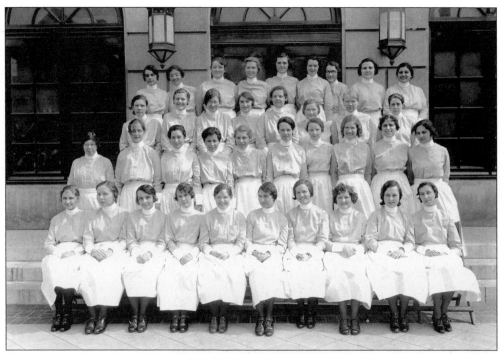

Shown is the Jersey City Hospital School of Nursing class of 1933.

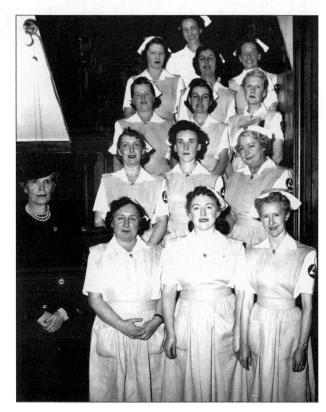

During World War II, the school of nursing provided training to civilians as part of a civil defense preparedness program and to assist in the hospital, where there was a shortage of nurses. Many nurses became part of the military nursing corps and were sent overseas.

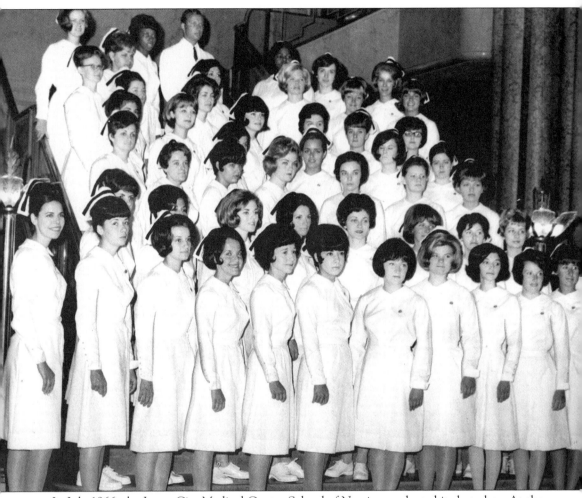

In July 1966, the Jersey City Medical Center School of Nursing graduated its last class. At the ceremony, 51 nurses were capped, including Gary R. Clarke, the one male nurse in the class.

# Five

# MEDICAL EDUCATION
## A PROUD HISTORY

It was not until 1954, when the Seton Hall College of Medicine and Dentistry was established under the auspices of the Roman Catholic Archdiocese of Newark, that New Jersey had its first accredited four-year medical and dental school.

The college became incorporated on August 6, 1954, and in September 1955, remodeling began on two buildings within the Jersey City Medical Center complex. The medical school operated from the clinic building, or building B, and the school operated from the old isolation building behind the surgical building. It was here that the first clinical and teaching facilities of the college were established.

In September 1956, the first class of 80 students was admitted to the four-year program. Between 1960, when the first class graduated, and 1964, the school awarded 348 individuals the degree of doctor of medicine. The majority of the graduates were New Jersey residents, many of whom continued their training at the Jersey City Medical Center and then went on to practice in Jersey City.

The first graduating class of dental students, in 1960, numbered 36 (35 men and 1 woman). By 1963, the graduates numbered 139. In addition to schools of medicine and dentistry, a graduate school of biomedical science was established at the same Jersey City Medical Center location, with the first candidates for the master's and doctoral degrees entering in 1962.

From its inception the school was never financially sound; it always operated in the red. In 1961, the Archdiocese of Newark realized that it could not continue to support the school's growing financial deficit, and it began contemplating closing the school. Discussions regarding the school's continued operation as a state institution began in 1964. Gov. Richard J. Hughes, with leaders of both parties from the state assembly and state senate, appointed a fact-finding committee to determine the feasibility of the state taking over the operations of the Seton Hall College of Medicine and Dentistry.

On July 28, 1964, the committee recommended that the state purchase the assets of the Seton Hall College of Medicine and Dentistry for $4 million and continue its operation under state control. This transaction was consummated on May 3, 1965, and the institution's name was officially changed to the New Jersey College of Medicine and Dentistry. The medical school continued to operate at the Jersey City Medical Center for another two years before relocating to temporary facilities in Newark. The dental school remained at the complex until 1975–1976, before relocating to the Newark campus.

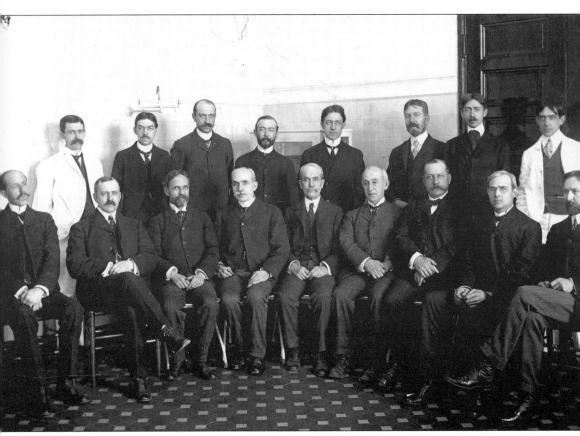

This is a photograph of the combined medical staff of the St. Francis Hospital and Jersey City Medical Center in 1909. The doctors are identified, from left to right, as follows: (first row) Parsons, Blanchard, unidentified, McLaughlin, John D. McGill, Mortimer Lampson, Parker, Faison, and Hill; (second row) unidentified, G. Culver, Brinkerhoff, Mooney, Hetherington, Daws, Hart, and unidentified. McGill was a leader in the fight against tuberculosis and was instrumental in the passage of the act that legalized the dissection of the human cadaver in New Jersey. In 1908, Lampson was appointed superintendent of the Jersey City Hospital. J. E. Culver, M.D., was a founding member of the Hudson County Medical Society in 1851.

This photograph is of the house staff of interns and residents at the Jersey City Hospital in 1916. The hospital's pediatric residency program is among the nation's oldest. In addition to pediatrics, the hospital offers programs in obstetrics and gynecology, internal medicine, general surgery, ophthalmology, and general dentistry and oral maxillofacial surgery. More than 100 residents and fellows attend programs.

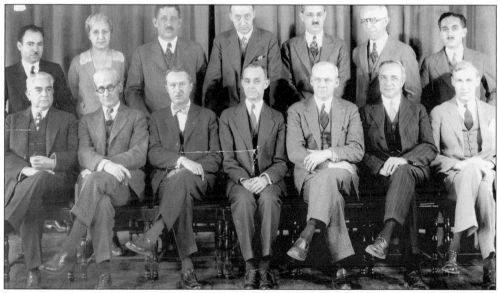

Shown is the 1928 medical staff. Dr. George O'Hanlon, medical director, is seated fourth from the left. Dr. Samuel A. Cosgrove, appointed chief obstetrician by Mayor Mark Fagan, is standing third from the left. Dr. A. E. Baffin is standing sixth from the left.

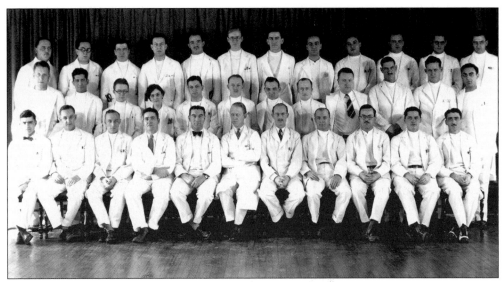

In 1866, there were some 600 regular physicians in practice in New Jersey. One was a woman. There were also irregulars physicians, practitioners such as homeopaths and eclectics, 23 of whom were women. Shown here are the 1930 Jersey City Medical Center residents and interns.

The state of New Jersey had no facilities for medical and dental education until 1954, when the Seton Hall College of Medicine and Dentistry was established under the auspices of the Roman Catholic Archdiocese of Newark and the leadership of Msgr. John Dougherty, 13th president of Seton Hall University. In September 1955, remodeling construction was begun in two buildings of the Jersey City Medical Center to house the clinical and teaching facilities of the college. (Courtesy of Seton Hall College of Medicine and Dentistry of New Jersey Records [RG/A], University of Medicine and Dentistry of New Jersey Libraries, Special Collections.)

Shown is the medical staff of 1930.

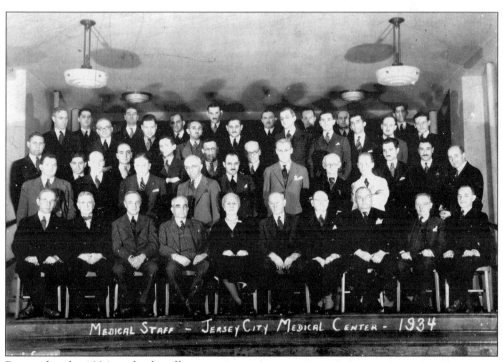

Pictured is the 1934 medical staff.

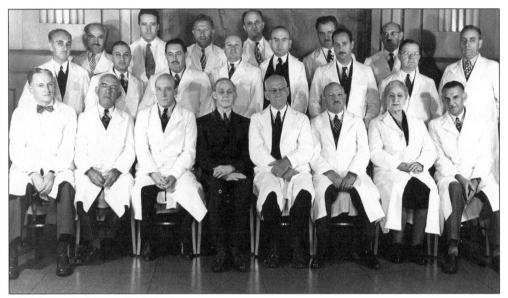

This the attending staff of 1947.

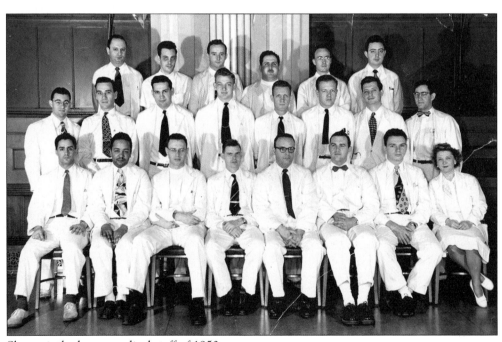

Shown is the house medical staff of 1950.

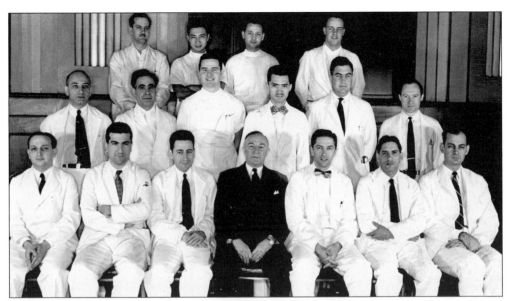

Doctors on the surgical staff in 1951 are identified as follows: (first row) Blasi, Guerra, Bruno, E. Shalligan (chief of surgical services), Costello, Nunes, and Longley; (second row) Trano, Vassiliades, Conroy, DelRosario, Meyerdierks, and Davies; (third row) Wu, Petrone, and Lewis.

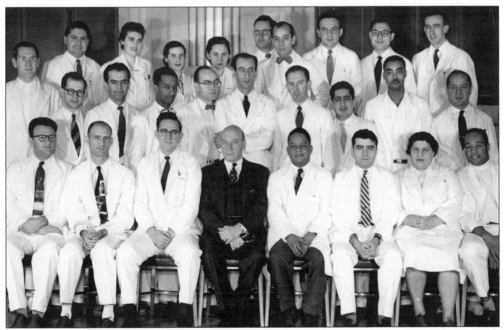

Residents and interns on the medical staff in 1953 are identified as follows: (first row) Leroy Hommer, Robert Richmond, Francis Donovan (chief resident), Carol Leevy (assistant chief of services), Martin Pollini, Lorise Fialkowski, and Randolph Johnson; (second row) John Stockfisch, Ilhan Trizel, Cahid Corbacioglu, Casper Omphroy, Carl Dvorschak, Abolghassem Ghaemi, Paul LaFlamme, Ezequiel Robletto, Ernest Simmons, and George Rienzo; (third row) Michele Scotto, Yvonne Imbleau, Maria Spatz, Lubomira Kocur, Leonard Rosen, Abbas Taleb-Zadeh, Alexander Kott, Jiro Nakano, and Robert Faber.

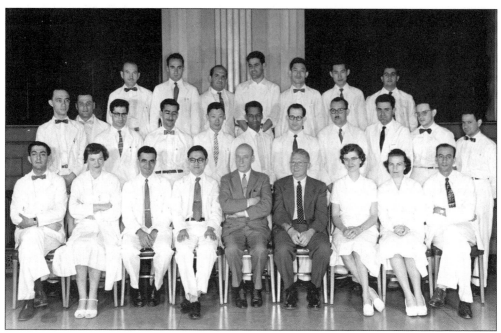

Pictured is the medical house staff in 1955–1956.

Surgical procedures were viewed from this observation gallery.

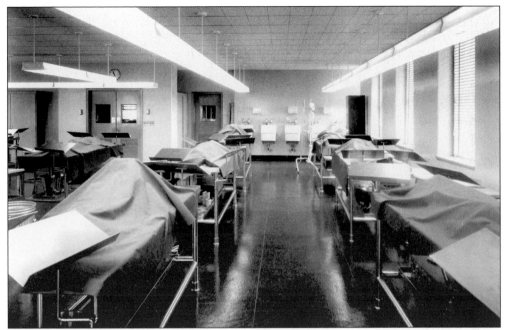

The medical school was fully equipped with various teaching laboratories, including this gross anatomy dissection laboratory on the 10th floor of the clinic building. (Courtesy of Seton Hall College of Medicine and Dentistry of New Jersey Records [RG/A], University of Medicine and Dentistry of New Jersey Libraries, Special Collections.)

The 16th floor of the medical school held a laboratory for research and animal experimentation. This included the use of dogs for learning surgical skills. (Courtesy of Seton Hall College of Medicine and Dentistry of New Jersey Records [RG/A], University of Medicine and Dentistry of New Jersey Libraries, Special Collections.)

Opened at the hospital in the late 1950s was a radioisotope center, was which was used to diagnose and treat cancer, heart disease, circulatory disorders, hyperthyroidism, and blood disorders. Among those responsible for setting up this department was Dr. Jonathan Gibbs, the first African American surgical resident at the Jersey City Medical Center. Gibbs, who slept in the basement, as he was not allowed in the residence hall with the other physicians, went on to become the first African American chief of surgery at the Jersey City Medical Center.

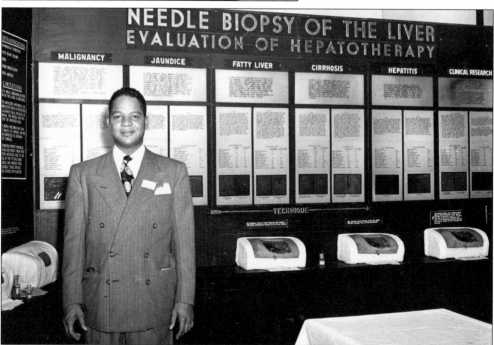

When Dr. Carroll Leevy was an intern and resident at the Jersey City Medical Center, he became interested in researching alcoholic liver disease because of the huge number of cases he treated. In 1948, he established the first clinic for alcoholic liver disease at the medical center and began investigating the mechanisms of the disease. He and a group of researchers found that alcoholic liver disease is due to an immunologic reaction to a breakdown product of alcohol. He also helped develop a technique to evaluate the liver's ability to repair itself by weighing the effectiveness of different drugs in treating the disease.

# Six
# EMERGENCY

Because of its proximity to the disaster, the Jersey City Medical Center was an integral part of the emergency response team mobilized to assist victims of the September 11, 2001, attack on the World Trade Center. The staff triaged thousands of people along the Hudson County waterfront and moved nearly 200 people to the hospital for additional treatment. Although many of the injuries were not life threatening, 12 patients were admitted with serious injuries. Due to the lethality of the event, very few additional casualties were subsequently seen; the hospital, however, remained in disaster deployment mode for an additional two days.

The Jersey City Medical Center serves as the advanced life support provider, paramedic, and backup 911-dispatch center for Hudson County. It also is the basic life support provider for Jersey City and Secaucus and the emergency medical technician training center. Physicians in every specialty are available around the clock, and the emergency room is totally integrated with the Mount Sinai School of Medicine's Emergency Medicine Department.

On May 13, 2004, Gov. James E. McGreevey presented $5 million to the Jersey City Medical Center for construction of its state-of-the-art trauma center. The 18,000-square-foot trauma center is designed to accommodate the second-busiest emergency care program in New Jersey—a program that serves more than 50,000 patients a year from Jersey City and the surrounding communities. Like the old hospital, the new one is a Level II trauma center. McGreevey dedicated the new facility to Port Authority heroes lost on September 11, 2001.

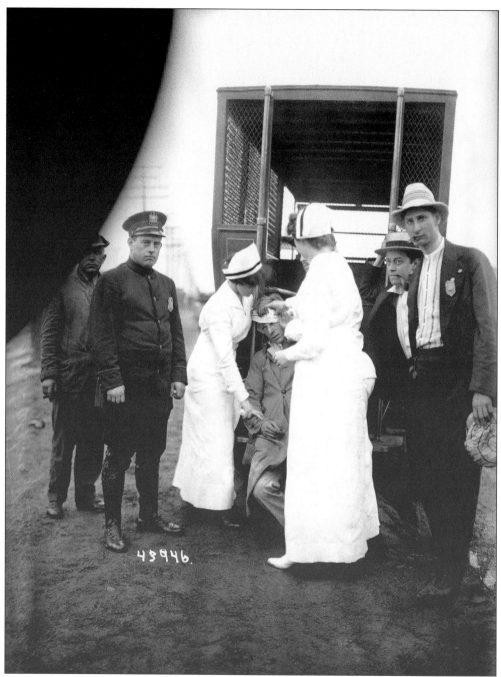

The Jersey City Medical Center has a long history of providing emergency care following disaster. Here, nurses and an ambulance crew treat a victim of the Black Tom explosion, on July 30, 1916. An explosion rocked Jersey City residents out of their sleep in the early morning, with several explosions to follow. The explosions took place at what was known as Black Tom Island—a mile-long pier that stood opposite the Statue of Liberty. The explosion was believed to be the result of the ammunition being set on fire, and it was also believed to be the work of German saboteurs who were protesting the British blockade of Germany.

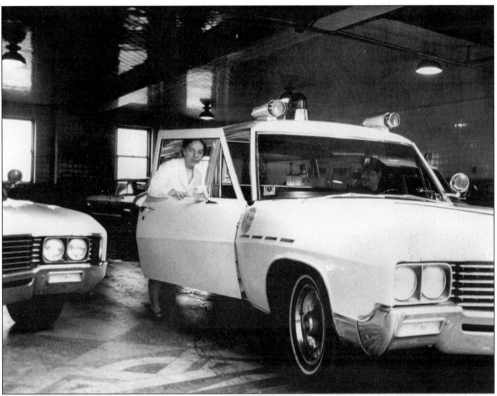

The Jersey City Medical Center was nationally known among physicians and hospital administrators for having a registered nurse in attendance on every ambulance trip.

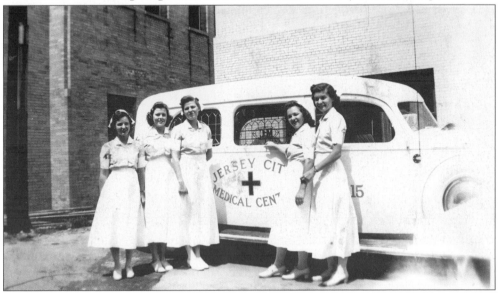

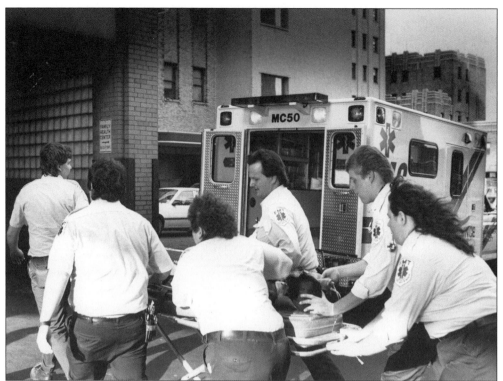

The Jersey City Medical Center has one of New Jersey's busiest emergency rooms with physicians in every specialty available around the clock. The emergency room is totally integrated with the Mount Sinai School of Medicine's Emergency Medicine Department.

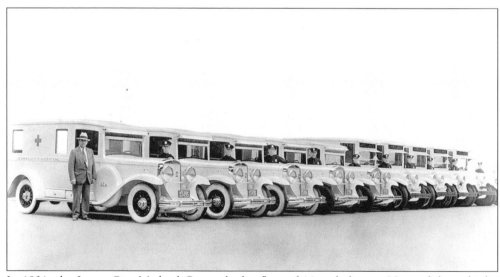

In 1931, the Jersey City Medical Center had a fleet of 11 ambulances. Nine of the vehicles served the medical patients of Jersey City, and two of them served the maternity cases of Hudson County residents. In 1930, more than 17,000 ambulance calls were logged by the hospital—approximately 47 calls a day, which was over three times the number of calls just 10 years earlier.

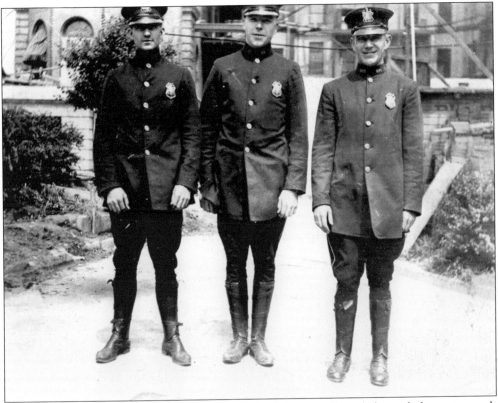

The central location of the Jersey Center Medical Center allowed the ambulance to reach almost any part of the city in rapid time. All of the ambulances were driven by regular city police officers.

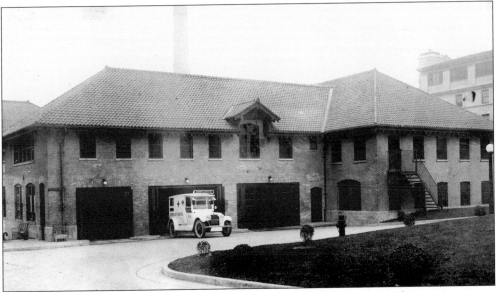

In 1954, a new garage was built to replace the one seen in this photograph. The new garage was needed to accommodate a greater number of ambulances.

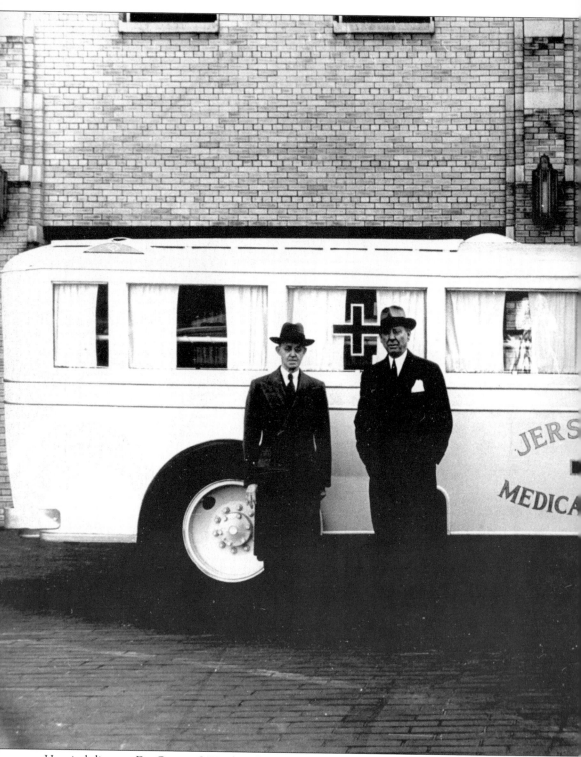

Hospital director Dr. George O'Hanlon (left) and Mayor Frank Hague stand in front of a long ambulance that contained four berths. Hague was always interested in bringing state-of-the-art

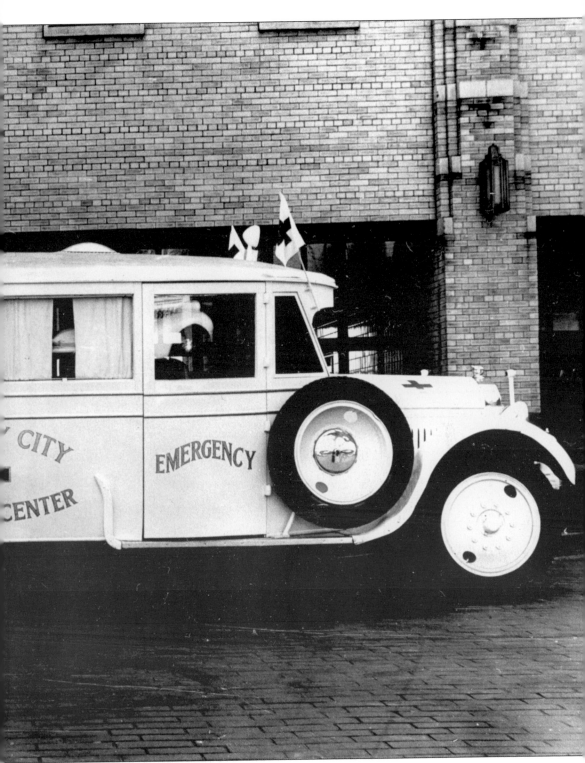

medicine to the Jersey City Medical Center.

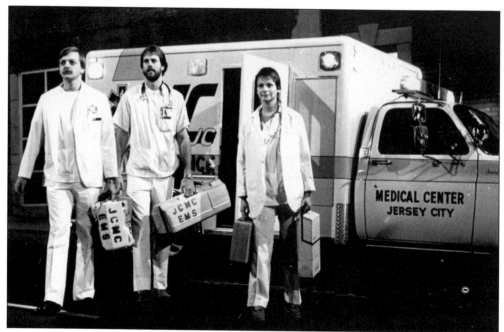

The Jersey City Medical Center serves as the advanced life support provider, paramedic, and backup 911-dispatch center for Hudson County. The hospital also is the basic life support provider for Jersey City and Secaucus and the emergency medical technician training center.

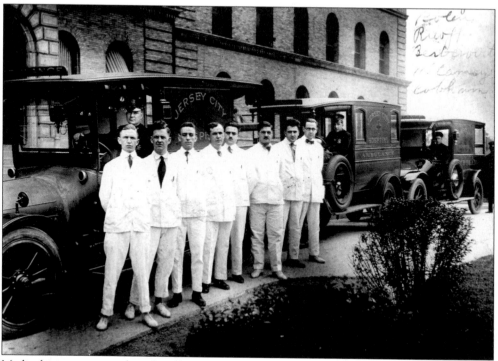

Medical interns are ready to board ambulances driven by Jersey City police patrolmen. Police officers drove the ambulances throughout the 1920s into the 1930s.

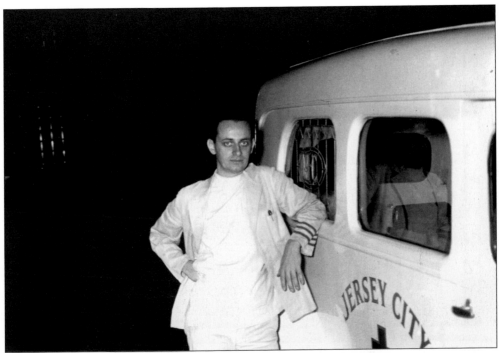

A medical intern gets ready to attend an ambulance call in 1920.

In the 1920s and the 1930s, interns rode along in ambulances as part of their training.

A city police officer dispatches an intern on an ambulance call.

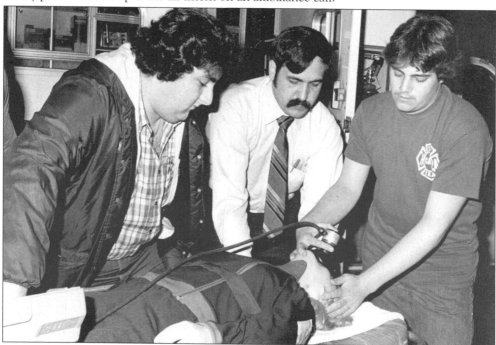

In 1998, the Jersey City Fire Department embarked on a new mission: to have its members trained as first responders and certified to use a defibrillator. In conjunction with the Jersey City Medical Center, 580 firefighters completed the 40-hour first responder program and the 8-hour defibrillator program. Each fire company has an automated external defibrillator. Firefighter training also included the proper administration of oxygen, as seen here.

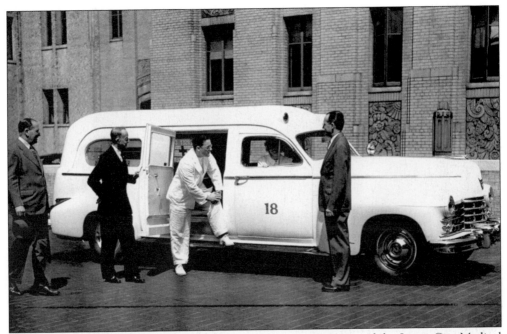

The upgrading of emergency equipment has always been a priority of the Jersey City Medical Center, even during difficult economic times. George O'Hanlon (with his hands on the door), medical director, inspects the newly arrived Cadillac ambulance in 1948.

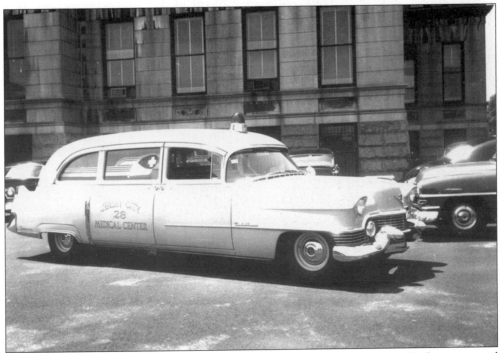

By 1954, new Cadillac ambulances were purchased. They were a far cry from the first motorized ambulance, which began operating in 1919. Prior to 1919, ambulances were horse drawn.

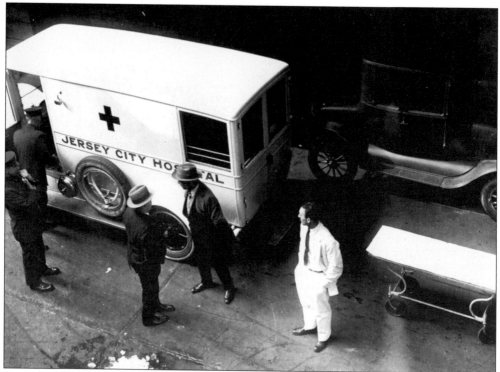

This c. 1930 photograph appears to be something out of an Eliot Ness movie, with police and what appear to be detectives hovering around a city ambulance in the emergency room area. Because the hospital served as Jersey City's emergency hospital, almost all victims of crime were brought there.

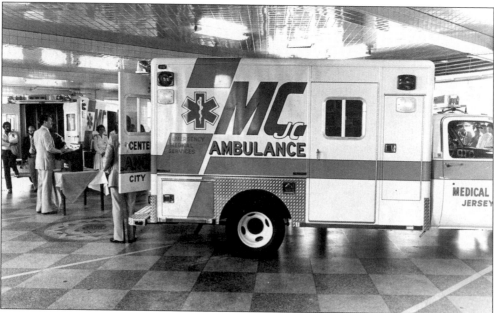

Mayor Gerald McCann looks over new ambulances c. 1990.

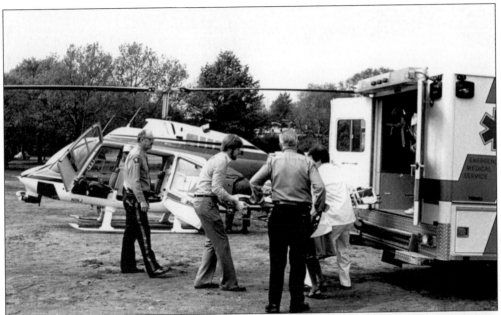

Between 2002 and 2003, the hospital handled 50,577 emergency room visits. The Jersey City Medical Center is Hudson County's state-designated Level II trauma center.

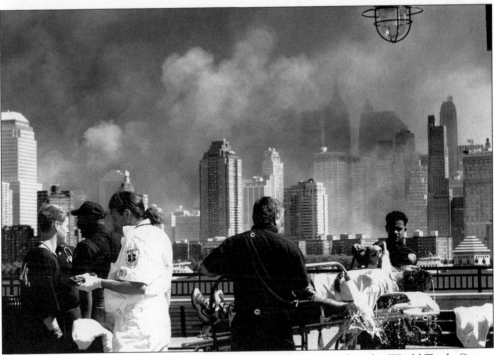

In 2001, a total of 970 people, including a number of those injured in the World Trade Center attack of September 11, were treated by the trauma center staff. Shortly after September 11, the Jersey City Medical Center set up a mobile command center and triage area at Liberty State Park and Ellis Island. The hospital supplied dozens of emergency medical technicians and paramedics, and even emergency room physicians.

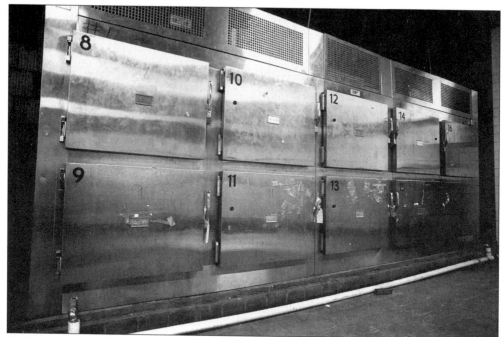

Unfortunately, the Jersey City Medical Center served not only as place for treating the injured after a disaster but also as a place where those who do not survive are kept awaiting retrieval by loved ones.

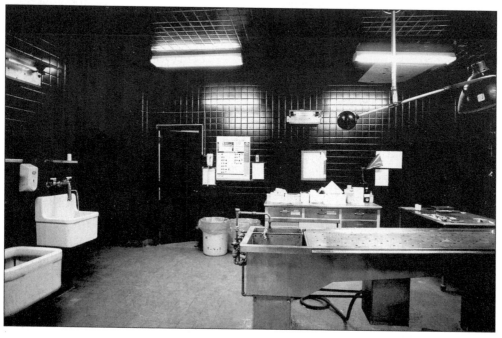

The Jersey City Medical Center had a fully equipped morgue, facilities for autopsy, an amphitheater for autopsy viewing by residents, and a specimen collection.

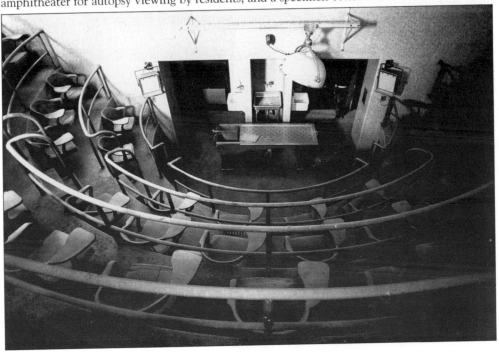

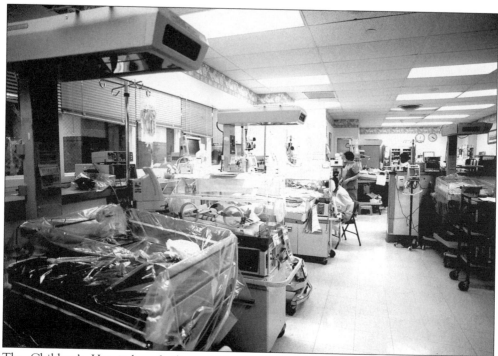

The Children's Hospital, a facility within the Jersey City Medical Center, provided 61 inpatient beds, an intensive-care nursery with 30 bassinets, a 24-bed intermediate unit, a fully staffed pediatric emergency medicine services. In May 2004, the hospital was moved to the newly constructed facility on Jersey Avenue.

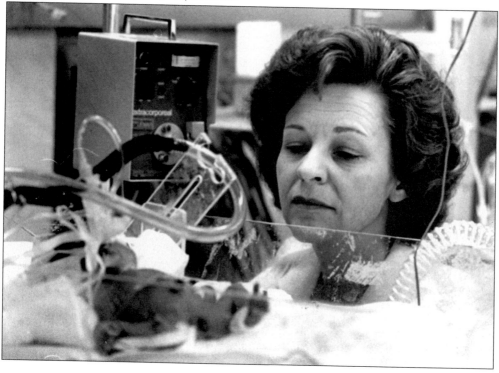

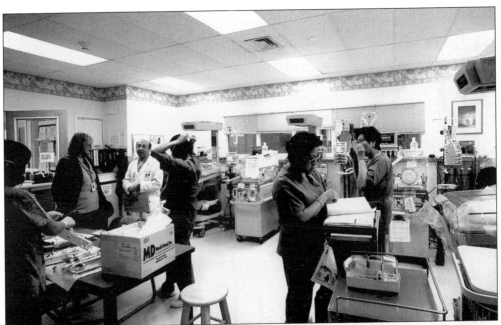

The Children's Hospital at the Jersey City Medical Center is the region's only pediatric intensive-care unit.

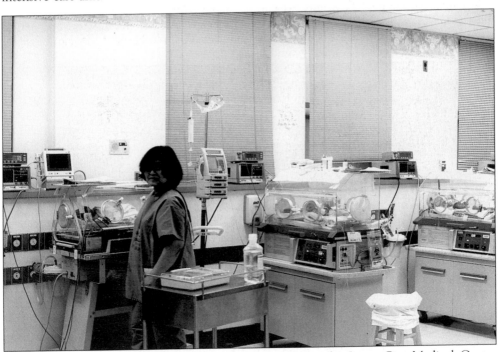

With almost 3,000 admissions and 34 outpatient clinics, the Jersey City Medical Center Children's Hospital is among the largest pediatric programs in New Jersey. It ranks second in New Jersey in emergency pediatric admissions. Three-quarters of all pediatric cases are Medicaid or Charity Care patients. The pediatric residency program is sponsored by the Mount Sinai School of Medicine.

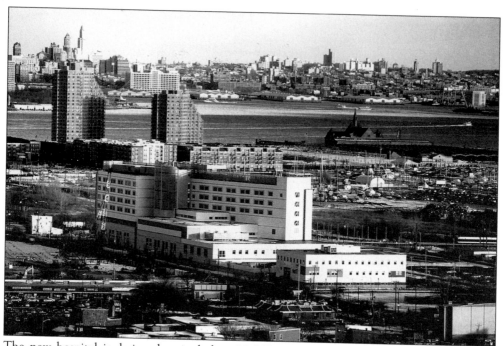

The new hospital is designed to include a 10,560-square-foot imaging center for radiology, CAT scanning, and MRI (magnetic resonance imaging), as well as an eight-room operating suite, with two of the rooms dedicated to open-heart surgery and trauma.

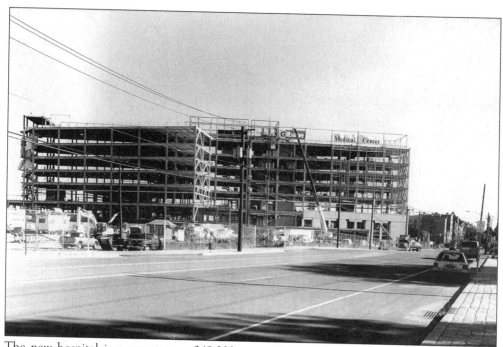

The new hospital is a seven-story, 349,000-square-foot, 326-bed acute care hospital with a 17,760-square-foot trauma center and emergency room.

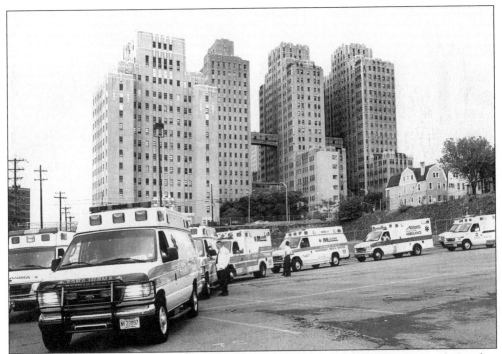

On Sunday, May 16, 2004, the Jersey City Medical Center closed its doors for good. On that day, a fleet of 55 ambulances pulled up in groups of four to the emergency room door and loaded patients into the vehicles for the short trip down the hill to the new hospital.

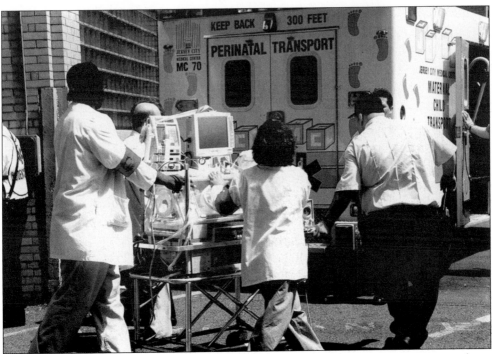

One of the smallest patients moved was this newborn baby, weighing just over one pound.

Jersey City resident Boushra Habib was the last patient to leave the old hospital for an ambulance ride to the new hospital.